Y O S E M I T E

A N S E L A D A M S

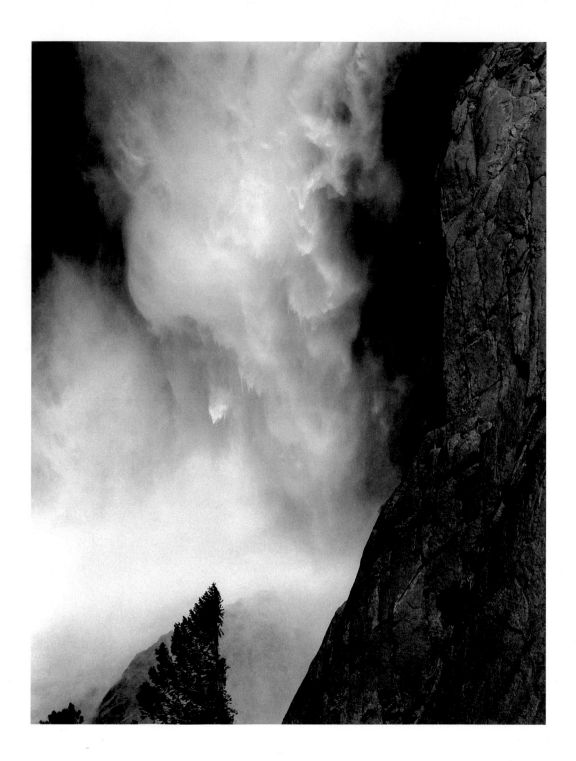

YOSEMITE

ANSEL ADAMS

Edited by Andrea G. Stillman
Introduction by Michael L. Fischer

Little, Brown and Company
New York • Boston • London

Little, Brown and Company

Hachette Book Group USA
237 Park Avenue, New York, NY 10017
Visit our Web site at www.HachetteBookGroupUSA.com

FIRST EDITION
Eighth Printing, 2008

Little, Brown and Company is a division of Hachette Book
Group USA, Inc. The Little, Brown name and logo are
trademarks of Hachette Book Group USA, Inc.

Library of Congress Cataloging-in-Publication Data

Adams, Ansel.
 Yosemite / Ansel Adams. — 1st ed.
 p. cm.
 Includes bibliographical references (p.) and
 index.
 ISBN 978-0-821-22196-9
 1. Yosemite National Park (Calif.) 2. Yosemite
National Park (Calif.) — Pictorial works. I. Title.
F868.Y6A356 1995
770'.92 — dc20 95-12010

Designed by John Kane
Printed by Meridian Printing

PRINTED IN THE UNITED STATES OF AMERICA

In 1976, Ansel Adams selected Little, Brown and
Company as the sole authorized publisher of his books,
calendars, and posters. At the same time, he established
The Ansel Adams Publishing Rights Trust in order to
ensure the continuity and quality of his legacy — both
artistic and environmental.

As Ansel Adams himself wrote: "Perhaps the most im-
portant characteristic of my work is what may be called
print quality. It is very important that the reproductions
be as good as you can possibly get them." The autho-
rized books, calendars, and posters published by Little,
Brown have been rigorously supervised by the Trust to
make certain that Adams' exacting standards of quality
are maintained.

Only such works published by Little, Brown and
Company can be considered authentic representations of
the genius of Ansel Adams.

*I would like to thank the many talented people who helped in
the preparation of this book: Virginia Adams, Janet Swan Bush,
Rod Dresser, Christina Eckerson, Dave Gardner, John Kane,
Jeff Nixon, Antonis Ricos, Alan Ross, John Sexton; and the
Trustees of The Ansel Adams Publishing Rights Trust: John
Schaefer, Bill Turnage, and David Vena.*
— A.G.S.

Front Cover: Mirror Lake, Mount Watkins, Spring, 1935.
Frontispiece: Base of Upper Yosemite Falls, c. 1948.
Back Cover: Ansel Adams photographing in Yosemite
Valley, 1944. By Cedric Wright.

Contents

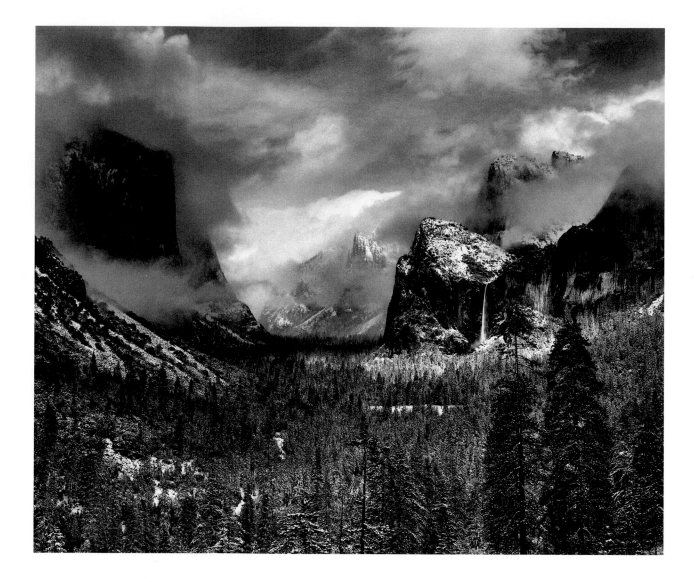

Clearing Winter Storm, 1944

If you were to give me the pleasure of showing you Yosemite Valley for the first time, I know just how I would want to do it. I would take you by night from the San Joaquin Valley up through the forested mountains and out to the Valley's rim, so that when sunrise came you would be standing on Glacier Point. Up before dawn, you would lean against the railing, trying to see down into the shadows for the first sight of something whose descriptions you never quite believed.

Perhaps a shining morning star would be burning in steel-blue space over the notched mystery of the horizon. Even by its light you could make out the great looming hulk of Half Dome, nearly 2,000 feet above our eyrie. I can well imagine your reactions with the coming of the first bit of sunlight. The constant thunder of the falls leads your eye to find their whiteness as the deep cut canyons are first illuminated.

Bit by bit, the obscuring darkness melts away, sculptured gray walls emerge, and the form and incredible depth of the canyons becomes apparent. You can begin to see where the heavy, scouring glaciers came grinding down the tributary canyons, to meet in a giant Y and gouge out the deep, straight-walled valley which lies more than 3,000 feet below our vantage point.

You suddenly become aware of a growing chorus of chirps and squeaks and scufflings as birds and squirrels begin to stir in the nearby trees. And soon afterward you see the first kindling of light on the summit crags of Mount Hoffman, far to the north across the canyon. Gradually the golden light reaches farther down the slopes, moving slowly over cliff and forest, firing every rock and tree into green-golden flame. Soon the shadows in which we stand will be swept away as the sun bursts upon us with an atomic blaze over the helmet curve of Half Dome.

—Ansel Adams
From "Yosemite," *Travel and Camera*, October 1946

Introduction

Michael L. Fischer

Yosemite. Ansel Adams. When either the place or the person comes to mind, it is easy—almost automatic—to think of the other. Ansel Adams and Yosemite are bound together in the American consciousness, and with good reason.

Ansel Adams, more than any other individual, brought Yosemite and the national park idea to the American people. His photographs, his letters, his lobbying of Congress, presidents, and the National Park Service, spanned seven decades. They served, and still serve, to make millions aware of Yosemite's beauty and to call attention to the dangers it faces.

A craggy-faced man with a sharp nose bent slightly to the left, Adams was gracious, warm, and welcoming. He made close friends and kept them; he welcomed new friends into his life. He was focused, energetic, and filled with good humor—a master of the pun. He cared about people, he cared about his friends, and he cared passionately about Yosemite.

As an artist—one of the best-known photographers in America—he celebrated the beauty of the natural world. In Yosemite, he found a deep wellspring of beauty to capture, to portray, and to share with the world. He demonstrated, through the pairing of his writing and his photography, that those who appreciate the earth's wild places have a duty and a responsibility to use them wisely and well.

In many ways, Ansel Adams' life revolved around Yosemite. He was smitten early—so much so that he was jokingly called "Ansel Yosemite Adams" in his midteens. He made his first photographs there at age fourteen, using a Kodak Box Brownie given to him by his parents, on the family's first vacation trip to Yosemite Valley. He managed the Sierra Club's LeConte Memorial Lodge for three years in his late teens, providing information and leading hikes for visitors to the Valley. He met and mar-

ried his wife, Virginia Best, there. He and Virginia lived there for months each year, from 1936 to 1946, he taking photographs while she managed Best's Studio—today's Ansel Adams Gallery.

Ansel later recalled his initial visit to Yosemite:

That first impression of the Valley—white water, azaleas, cool fir caverns, tall pines and stolid oaks, cliffs rising to undreamed-of heights, the poignant sounds and smells of the Sierra, the whirling flourish of the stage stop at Camp Curry with its bewildering activities of porters, tourists, desk clerks, and mountain jays, and the dark green-bright mood of our tent—was a culmination of experience so intense as to be almost painful. From that day in 1916, my life has been colored and modulated by the great earth-gesture of the Sierra.[1]

After that first vacation, he returned to Yosemite again and again, year after year. He was devoted to sharing Yosemite with others—even millions of others—but he reserved sharp scorn for those who would overdevelop, overuse, or otherwise spoil the very virtues of the national park to which he dedicated so much of his life.

In his essay *The Rediscovery of North America*, Barry Lopez speaks of the Spanish concept of *la querencia*, "a place on the ground where one feels secure, a place from which one's strength of character is drawn."[2] For Ansel Adams, Yosemite became *la querencia*, his "own place," which he was able to love, describe, share, and protect.

Ansel Adams employed Yosemite's special light in his photographs, writing, early in his career:

The silver light turned every blade of grass and every particle of sand into a luminous metallic splendor; there was nothing, however small, that did not clash in the bright wind, that did not send arrows of light through the glassy air. I was suddenly arrested in the long crunching path up the ridge by an exceedingly pointed awareness of the light…. I saw more clearly than I have ever seen before or since….[3]

Adams also recognized that photographs could not convey the full experience of Yosemite. Describing his first trip into the high country, above the Valley, he marveled at "the absolutely pure air and clean dawn wind and the glowing sunrise on these warm-toned peaks, and the sound of the river and the waterfall—the whole thing created an impact which was quite overpowering. I've never been able to put that particular experience in a photograph because it was so complex."[4]

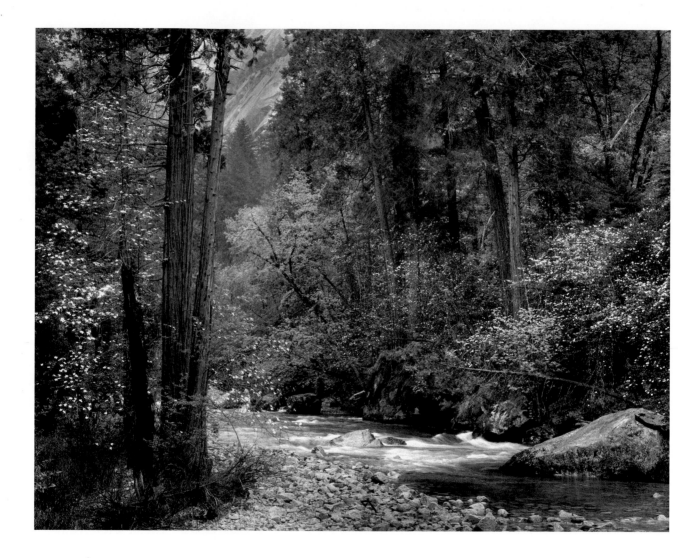

Tenaya Creek, Dogwood, Rain, 1948

The purpose of this book is to carry Adams' gifts and experiences forward, to serve as an extension of his work and to elicit a broad recognition that Ansel Adams' objective—the protection of this unique place—is not accomplished. Yosemite is still at risk.

Adams knew that Yosemite was not being managed as a national park should be. He felt that the Park Service was seeking to entertain the tourist, instead of maximizing Yosemite's "intangible benefits": opportunities for contemplation, for self-discovery, for inspiration. The truly visionary manager of Yosemite would first protect the natural world of Yosemite—its wilderness, its habitat diversity, its scenic integrity. *Everything* else would come second. But the National Park Service has never gotten that vision.

Instead, a trip to Yosemite Valley in the wintertime can seem like a trip to any other crowded, commercial ski resort. A summertime visit will find campgrounds clogged and lines of traffic and smoke filling the Valley, completely hiding its grandeur. Even the casual visitor, not really knowing what to expect, is struck by the fact that the concessionaire wishes to maximize the numbers of visitors who shop at the gift stores or enjoy expensive restaurant meals.

Adams devoted much of his life to fighting the historic compulsion of the National Park Service and its concessionaires to turn this magnificent natural resource into a resort. He knew he was fighting a losing battle as long as the Park Service turned to private-sector concessionaires (who must seek to realize the maximum return on their investment) to manage Yosemite. They demanded—and got—their own terms, by and large. That remains the case today.

As he wrote in 1958:

There is not one among us who should not bow his head in shame at the failure of basic planning, at the inadequate sensitivity, and at the opportunism which are so shockingly revealed in Yosemite today.... Those are hard words; I write them with conviction, regret and remorse. I write them also with some hope they may point out that the Yosemite disaster should stand as a warning against further depredations of the natural scene.[5]

And: "If you are to accuse any 'body' or organization for the present situation in Yosemite, I think you must first put the finger on the NPS."[6]

Adams' recognized artistic leadership was coupled with his standing as an advocate, an activist seeking to promote the values of wilderness and the natural world. His letters (selections of which appear at the back of this book) display anger and indignation over incompetent or misguided park service management, the occasional exhilaration of an engaged lobbyist, and the discouraged resignation caused by political failure.

Ansel Adams was the best-known American environmentalist since John Muir. Like Muir, he used his prestige to gain the ear of government leaders and to spread his strong message in the national media. Trips to Washington, D.C., became regular occurrences. Letters to senators, members of Congress, cabinet secretaries, directors of federal departments, and presidents, dated from the 1930s to the 1980s, fill his files. For decades, he was the only environmentalist who could pick up the telephone and gain access to the Oval Office.

The letters also make clear his keen insight, his confident judgment, of what was necessary for Yosemite: Save it from economic success. Protect it from becoming merely an overcrowded playground, a resort. Remove the automobile from most of the Valley. Reduce camping and other overnight accommodations. Ban wood campfires. Eliminate entertainment events designed to attract casual tourists. And limit day-use visitation. This was strong medicine!

Why was—and is—Adams' strong medicine necessary? As Len McKenzie, the former chief naturalist for Yosemite, put it:

In our work, we try to enhance visitor understanding and appreciation of Yosemite and to provoke in people a sense of inspiration. It's difficult to do that with visitors who are not receptive to it, or who don't have the time. The Park Service has developed the Valley to accommodate visitor use, and the park now attracts people who are insulated from the natural world by an unnecessary comfort zone of development. Many people are reluctant to get too far from their cars. It's frustrating to see the superficial ways in which many people use the park and to be unable to influence their perceptions or behavior.[7]

In other words, the Park Service has created—or allowed the creation of—a pattern of use and development in Yosemite that tends to trivialize the very values this place has to give to the modern world. Adams' prescription: limit the number of people who enter the Valley and remove the commercial impediments that prevent them from entering into its sanctity.

Building on his experience of the power and impact of photography to move political officials, Adams sought other opportunities to get his message to many more people. Thirty-five years after becoming the summer custodian of LeConte Lodge, Adams created a photographic exhibit to inspire America toward a new land ethic. While he had been urging the Sierra Club to mount such an exhibition for some years, the final impetus came, in part, from the lodge itself. It had fallen into sufficient disuse that the Park Service was threatening to terminate the Sierra Club's tenancy; so Adams proposed to mount a major photographic exhibition there. It proved even more influential than he had hoped.

Enlisting the assistance of his close friend and collaborator, writer Nancy Newhall, Adams designed *This Is the American Earth*. The exhibit was so impressive that, after its time in Yosemite Valley, it toured the capitals of the world under the auspices of the Smithsonian Institution and the U.S. State Department. In 1960, after Newhall and Adams expanded and reworked the exhibit material into book form, *This Is the American Earth* became the Sierra Club's first exhibit-format book. It was, arguably, the most successful example yet of the arts of photography and poetry joined in advocacy, documenting both the beauties of the earth and the ravages created by a thoughtless, greedy, and too-populous humankind.

The book and the exhibition were important on two levels. Adams had been criticized by fellow artists, repeatedly and pointedly, for devoting his career to the "transient and ephemeral." Henri Cartier-Bresson, disapproving of Adams' seeming disengagement from social problems, said, "Now, in this moment, this crisis, with the world maybe going to pieces—to photograph a *landscape!*"[8] *This Is the American Earth* demonstrated Adams' keen understanding of the relevance of his vision to the destructive pattern of life, development, and urbanization which mankind was visiting upon the earth, and it gave the gift of a different and better vision.

On the second level, *This Is the American Earth* joined the influential *Sand County Almanac* by Aldo Leopold in pointing the way to a new, more sensitive future on earth for a populous humankind. With its dramatic photographs of both beauty and destruction, and with its specific prescriptions, *This Is the American Earth* made the vision clearer, more palpable. With its publication, "ecology"— the study of mankind's relation to the earth—took on a more pragmatic, less academic, meaning.

Just as Yosemite changed Ansel Adams' life, *This Is the American Earth* was an instrument he used to change the lives of others. It certainly changed mine. Twenty years old when it was published, I was

searching for a life-goal and a career. My mother gave me a copy; I devoured it eagerly and with growing excitement. I showed it to my college guidance counselor, saying, "*this* is what I want to do!" Neither of us then knew the term *environmentalism*. She suggested a degree in political science and added that I should "think about city planning."

I followed her advice. Five years later, having obtained my political science degree, I was bound for the University of California to pursue my graduate degree in city and regional planning. While looking for an apartment, I unexpectedly sat next to Ansel Adams at the counter of a hamburger stand. I had the opportunity to tell him that I was there, in Berkeley, because of his book, his inspiration. Characteristically, he was gracious and interested in my plans. He gave his address in Carmel, inviting me to "stop by sometime." Fifteen years later, I did. In the early 1980s, as executive director of the California Coastal Commission, I found myself several times in Adams' home having dinner and plotting strategy to create a Big Sur National Scenic Area. In the early 1990s, as the executive director of the Sierra Club, I had the privilege of working with The Ansel Adams Publishing Rights Trust to republish *This Is the American Earth* on the occasion of the club's centennial.

Adams' vision for Yosemite kept alive that of another leader who preceded him to Yosemite by a half-century: Frederick Law Olmsted. In 1864, President Lincoln had signed legislation reserving Yosemite as an area to be protected as part of the nation's public trust, to be owned and administered by the State of California. To help carry out that responsibility, Governor Frederic F. Low appointed Olmsted, who had just completed plans for Central Park in Manhattan, chair of the Board of Yosemite Valley Commissioners. In 1865, he stood in the Valley and read his remarkably prescient report to the assembled commission:

The first point to be kept in mind, then, is the preservation and maintenance as exactly as is possible of the natural scenery; the restriction, that is to say, within the narrowest limits consistent with the accommodation of visitors, of all constructions markedly inharmonious with the scenery or which would unnecessarily obscure, distort or detract from the dignity of the scenery.... Before many years, if proper facilities are offered, these hundreds of visitors will become thousands and in a century the whole number will be counted in the millions. An injury to the scenery so slight that it may be unheeded by any visitor now, will be one of deplorable magnitude when its effect upon each visitor's enjoyment is multiplied by those millions.[9]

Arriving in Yosemite Valley four years later and viewing the already apparent failure of state management of this national treasure, John Muir devoted a large part of *his* life to the creation of a national

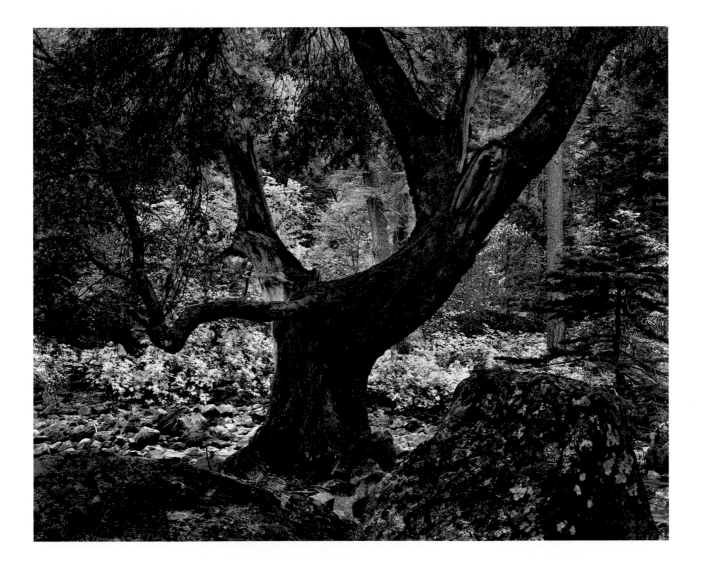

Late Autumn, Evening, Merced Canyon West of Ribbon Creek, 1944

park, modeled on the Yellowstone experiment. The pressure of his constant stream of articles, letters, and personal lobbying worked: In 1890, Congress set aside the wilderness surrounding the Valley as Yosemite National Park. But very quickly thereafter, Muir and some friends realized the new threat and formed the Yosemite Defense Association which, in 1892, was incorporated as the Sierra Club.

Why? In Muir's own words, written years later: "National Parks have always been subject to attack by despoiling gain-seekers and mischief-makers of every degree from Satan to Senators, eagerly trying to make everything immediately and selfishly commercial. Thus," he continued,

long ago a few enterprising merchants utilized the Jerusalem temple as a place of business instead of a place of prayer.... Ever since the establishment of Yosemite National Park, strife has been going on around its borders and I suppose this will go on as part of the universal battle between right and wrong, however much its boundaries may be shorn or its wild beauty destroyed.[10]

Adams, too, sought to have the moneychangers driven out of the temple. In 1976 he wrote to Ed Hardy, chief operating officer of the Yosemite Park and Curry Company, the principal concessionaire:

I have ALWAYS believed that private business is questionable in terms of "controlling" the public services in the National Parks. To be more precise, I would say that the concept of this management is wrong.... I think it is simply this: you ARE in Yosemite on the basis of the present concessioner system.... I would say that you are doing an appropriate job—as you should be doing. This is an entirely different matter from my basic theoretical concept that we ALL should NOT be in Yosemite. And this includes The Ansel Adams Gallery!...[11]

This was not a new realization. Almost thirty years earlier, after watching the gradual but excessive development of Yosemite, he wrote, in 1948, a brief introduction to *Yosemite and the Sierra Nevada* (a book of his photographs and selections from Muir's works):

...Peril lies in the desecration of intangible elements (of our national parks) through resortism and commercialized recreation—often disguised as "public service." Vision and fine restraint are needed lest this predatory commercialism violate the fartherest recesses of granite, the last meadow, the ultimate fountains of life-giving streams, with no one realizing before it is too late that to jostle is to change, to overrun is to destroy.[12]

Adams protested, often and vigorously, but nothing of real substance changed. The National Park Service simply had a *different* national park concept.

In 1973, the Music Corporation of America saw Yosemite for what it had become: a significant amusement, entertainment, and hotel "property." It purchased the Yosemite Park and Curry Company (YPCC), which by then had exclusive long-term concession rights over all park lodging and restaurants. Calling Yosemite a "destination resort," MCA openly lobbied for expansion of commercial opportunities in the park. Television programs, movies, advertising backgrounds, were all in their plans. For a short time, movie crews were painting the rocks to make them more attractive on the screen. MCA vigorously promoted the idea of a gondola tramway from the Valley floor to Glacier Point. When the Park Service announced a plan to reduce automobile traffic in the Valley, the MCA president of YPCC criticized it, saying that congestion was only a problem because the service had failed to build enough parking lots. Here was demonstrated another classic, tragic, failure to grasp the concept.

In 1980, the Park Service released its General Management Plan for Yosemite National Park. (The plan is still current.) The plan's basic tenets looked good on the surface. As it states, visitors should be able to "step into Yosemite and find nature uncluttered by piecemeal stumbling blocks of commercialism, machines and fragments of suburbia."[13]

The plan proposed to move most of the rangers' and employees' residences, offices, and warehouses out of the Valley, to reduce the number of overnight accommodations, and to ultimately close the Valley to the automobile. Not since Olmsted's 1865 report had there been such an exposition of the problems facing Yosemite, nor such a search for balance between preservation and use. However, the details of the plan failed to live up to its vision. Just as important, the Park Service was politically and intellectually incapable of forcing the concessionaire to make the necessary changes.

Adams knew from the beginning that the plan was not visionary. He saw it as a weak bureaucratic compromise. It failed, in his view, to see the dividing line between resortism and the protection of a resource which belongs to all species and, essentially, to the future. Even this better-than-average plan fails by trying to reconcile the ultimately incompatible interests of the concessionaire and the protectionist. A compromise solution in the end favors the concessionaire.

To protect the resource, to make possible the inspiration of the visitor, Adams believed a successful plan must strictly limit the number of visitors. He wrote to the director of the National Park Service: "Limitation of visitation is an essential reality! I often use the simile of the opera house; all

seats are sold and some standing room as well. That is the limit; we do not sell lap-room! If we accepted more people than space would permit, the performance would be ruined for all."[14]

And several months later, he wrote to a Sierra Club leader:

I was bitterly disappointed over the failure of the Service to initiate a truly strong plan. There is no clean-cut plan to reduce services and accommodations within the Valley itself. The hint of a number of new rooms (ostensibly to replace tents) merely promises greater difficulty in the ultimate goal of simplification. There is a frightening lack of imagination.[15]

Adams had earlier written to Sierra Club leaders complaining about their readiness to compromise with the Park Service:

I think we must take the attitude that—in the face of the enormous spiritual and inspirational value of the Parks and the wilderness areas—no bureau, no plan, no established project, no road, no concessionaire, no works of man of any kind has consequential value. We must proceed as if all of these factors did not exist. They are expendable—the parks are not.[16]

From these excerpts of his letters, one might get the impression that Adams was an angry man, given to adversarial diatribe. This was not so. He was a gentleman—warm, humorous, patient, and pleasant. He had the rare ability to disagree firmly, even dramatically, without being disagreeable. This ability, coupled with the obvious sincerity of his concern for the public good, gave him access to all who needed to hear him.

Ansel cared about Yosemite as it would be experienced—not just seen, but *experienced*—by people, one at a time. He sought for each person the space, the time, the freedom from distraction, to find in Yosemite the peace and spiritual growth which he himself had found. His magnificent photography brought him access to the media and to powerful leaders; his warmth of personality earned their trust and confidence; the emotion and knowledge he brought to his conversations gave credence to his suggestions; his persistence, determination, and energy made things happen. Most of all, his keen eye for the clear, unalloyed beauty in a wilderness landscape—and his ability to share that essence—gives us a vision for Yosemite on which to base our own actions.

Ansel Adams' gift to us was that clear vision of beauty, his vision of a sustainable relationship between mankind and our earth. His life was filled with love for Yosemite and for its open window to the magical beauties of wilderness and the natural world. He gave us appreciation and drama, and he gave us anger, determination, and tough talk. He urged us to strive for high standards in the protection of the "intangibles."

"We either have wild places or we don't," he said. "We admit the spiritual-emotional validity of wild, beautiful places or we don't. We have a philosophy of simplicity of experience in these wild places or we don't. We admit an almost religious devotion to the clean exposition of the wild, natural earth, or we don't."[17]

And, again: "We need fire, not glowing embers! We do not need hyperbole or bantering. I am waiting for a bit of wrath and outrage, expressed in the consistent mood of dignity and concern, impact and compassion. Like a full orchestra, not just a string quartet!"[18]

In a letter to Adams about a draft of *This Is the American Earth*, photographic historian Beaumont Newhall wrote: "In the face of all the present turmoil and unrest and unhappiness…what can a photographer, a writer, a curator do?… To make people aware of the eternal things, to show the relationship of man to nature, to make clear the importance of our heritage, is a task that no one should consider insignificant…. These are days when eloquent statements are needed."[19]

Ansel Adams gave us those eloquent statements—in his words, in his photographs, and in the example of his life.

1. In Charlotte E. Mauk, ed., *Yosemite and the Sierra Nevada: Selections from the Works of John Muir* (Boston: Houghton Mifflin, 1948), p. xiv.

2. Barry Lopez, *The Rediscovery of North America* (New York: Vintage Books, 1992), p. 39.

3. Ansel Adams, *Yosemite and the High Sierra,* Andrea G. Stillman, ed., introduction by John Szarkowski (Boston: Little, Brown, 1994), p. 20.

4. Ibid., p. 125.

5. "Yosemite—1958: Compromise in Action," *National Parks Magazine* 32:135 (October-December 1958), p. 166.

6. Letter to Robert E. Wilson, April 4, 1976.

7. William Neill, *Yosemite: The Promise of Wilderness* (Yosemite National Park: Yosemite Association, 1994), p. 66.

8. Quoted in Adams, op. cit., p. 18.

9. Frederick Law Olmsted, *Yosemite and the Mariposa Grove: A Preliminary Report, 1865* (Yosemite National Park: Yosemite Association, 1993), pp. 21, 23.

10. John Muir, *The Yosemite*, photographs, introduction, and captions by Galen Rowell (San Francisco: Sierra Club Books, 1989), p. 216.

11. Quoted in Andrea G. Stillman and William A. Turnage, eds., *Ansel Adams: Our National Parks* (Boston: Little, Brown, 1992), p. 121–122.

12. Mauk, op. cit., p. i.

13. U.S. National Park Service, *Visitor Use, Park Operations and Development Plan, Yosemite National Park* (Washington, D.C.: U.S. Department of the Interior, NPS, September 1980), p. 1.

14. Letter to William Whalen, July 15, 1979. Quoted in Mary S. Alinder and Andrea G. Stillman, eds., *Ansel Adams: Letters and Images, 1916–1984* (Boston: Little, Brown, 1988), p. 353.

15. Letter to Edgar Wayburn, April 27, 1980. Quoted in ibid., p. 358.

16. Letter to Harold Bradley, Richard Leonard, and David Brower, July 27, 1957. Quoted in ibid., p. 248.

17. Andrea G. Stillman, ed., *Ansel Adams: The American Wilderness* (Boston: Little, Brown, 1990), p. 95.

18. *Ansel Adams, An Autobiography* (Boston: Little, Brown, 1985), p. 355.

19. Letter from Beaumont Newhall, May 3, 1955. Quoted in Robert Dawson, et al., *Ansel Adams: New Light, Essays on His Legacy and Legend* (San Francisco: Friends of Photography, 1993), p. 72.

Y O S E M I T E

That first impression of the Valley—
white water, azaleas, cool fir caverns, tall pines and stolid oaks,
cliffs rising to undreamed-of heights, the poignant sounds and smells of the Sierra…
was a culmination of experience so intense as to be almost painful.
From that day in 1916, my life has been colored and modulated
by the great earth-gesture of the Sierra.

From the Introduction to
Yosemite and the Sierra Nevada:
Selections from the Writings of John Muir, 1948

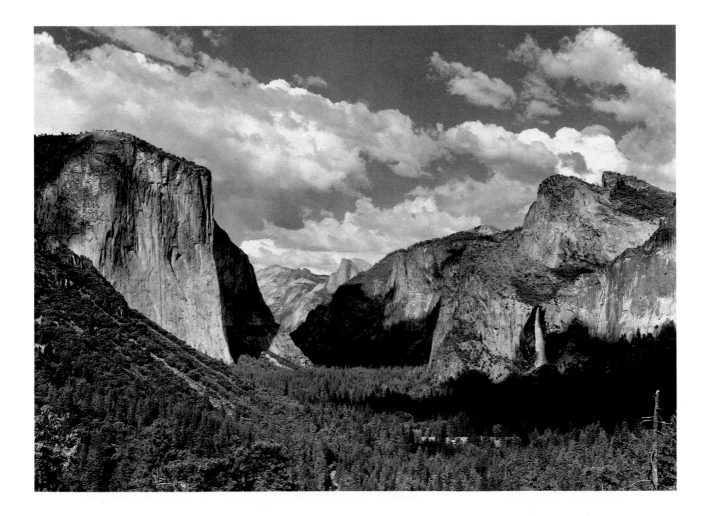

Yosemite Valley, Summer, c. 1936

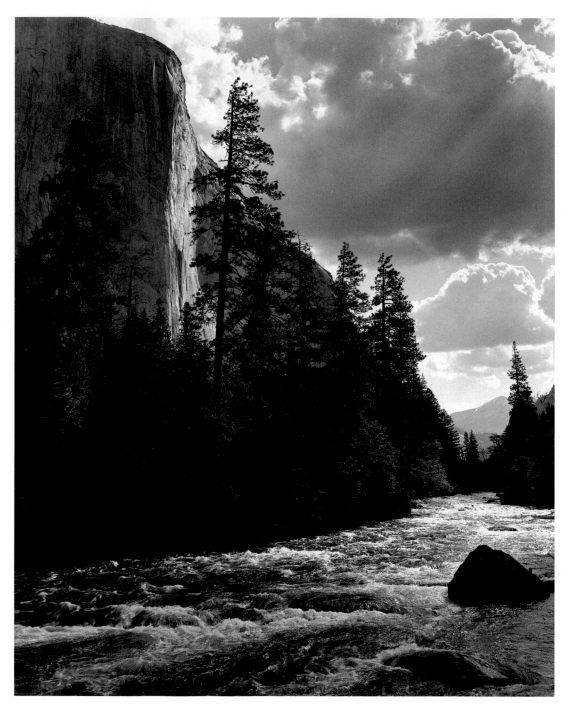

El Capitan, Merced River, Clouds, 1948

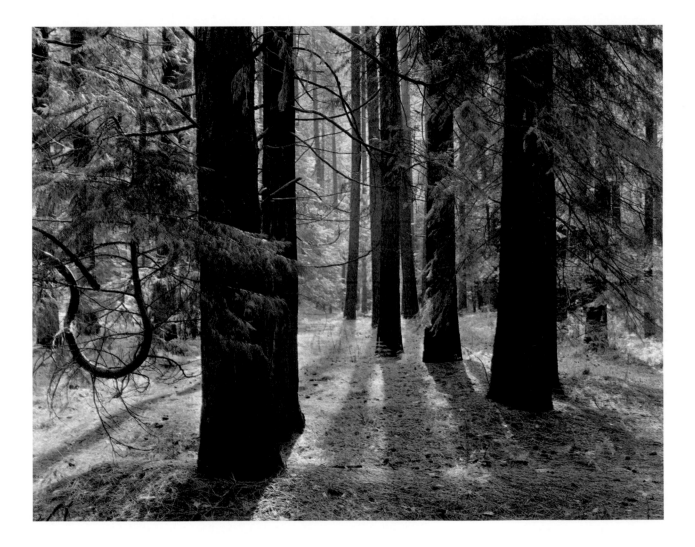

Forest Floor, c. 1950

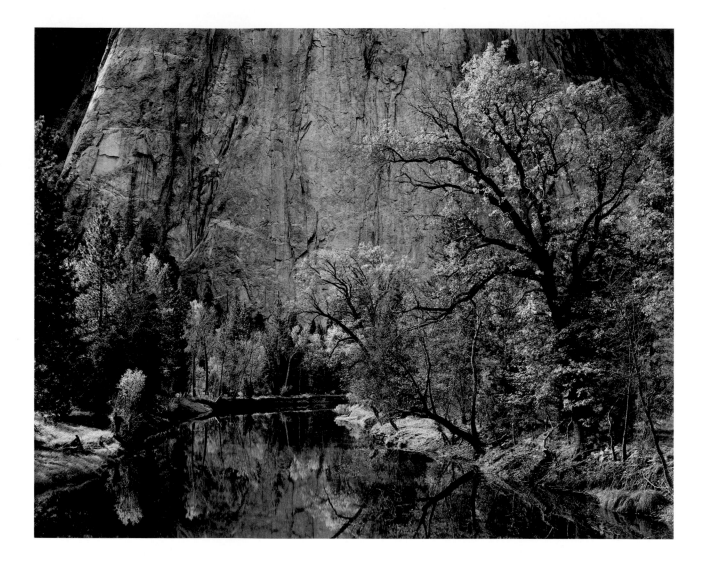

Merced River, Cliffs, Autumn, 1939

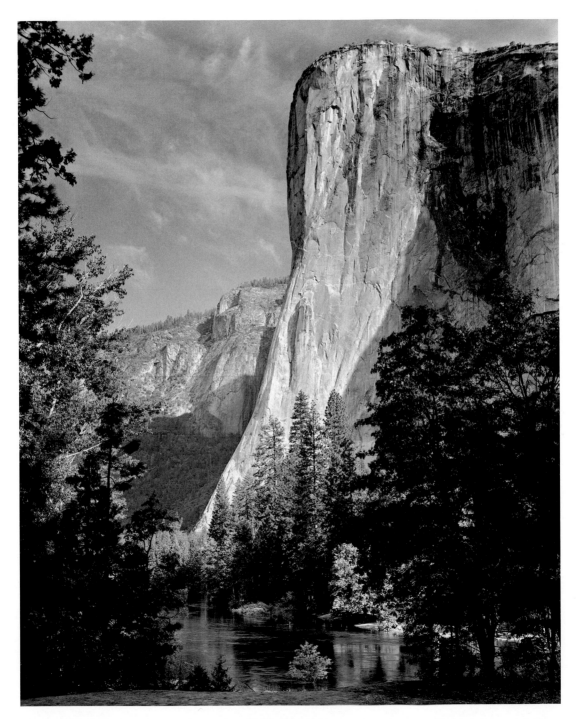

El Capitan, 1952

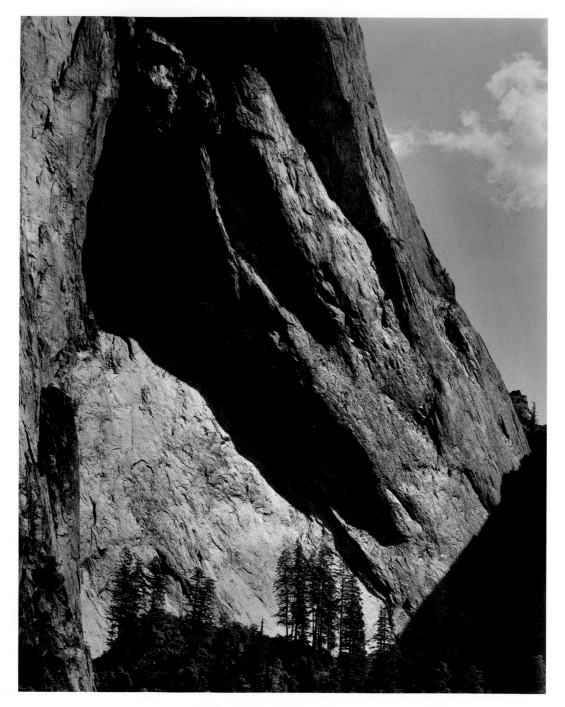

Cliffs of Cathedral Rocks, c. 1942

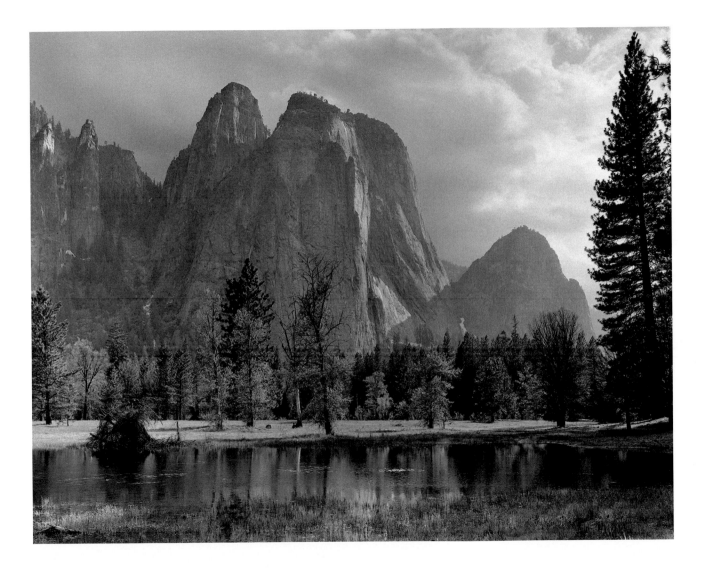

Cathedral Rocks, c. 1949

The great rocks of Yosemite,
expressing qualities of timeless, yet intimate grandeur,
are the most compelling formations of their kind.
We should not casually pass them by
for they are the very heart of the earth speaking to us.

From *My Camera in Yosemite Valley,* 1949

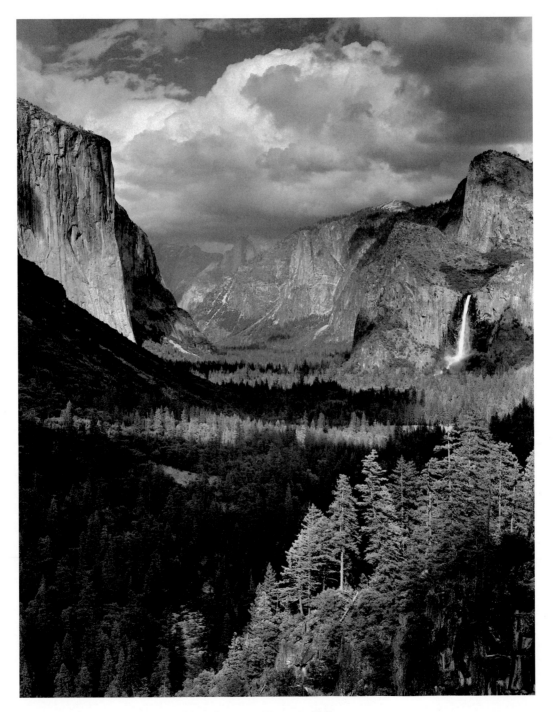

Thunderstorm, Yosemite Valley, 1945

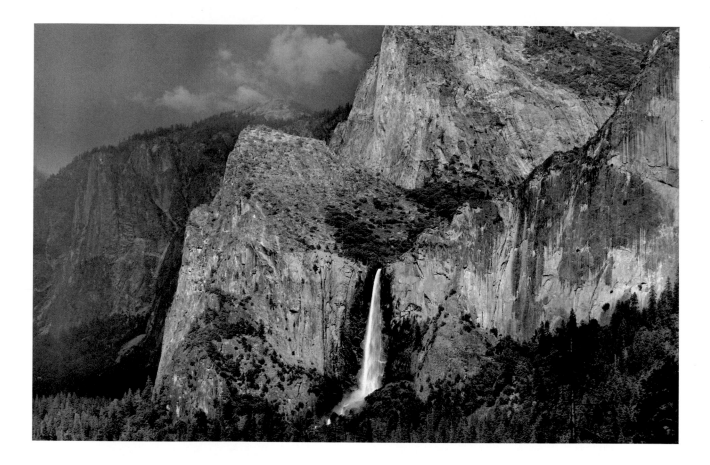

Bridalveil Fall and Cathedral Rocks, Thunderstorm, c. 1942

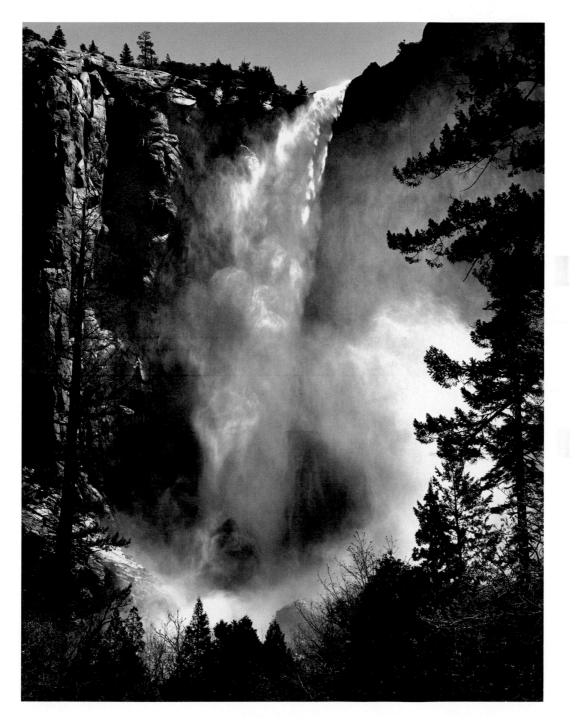

Bridalveil Fall, 1927

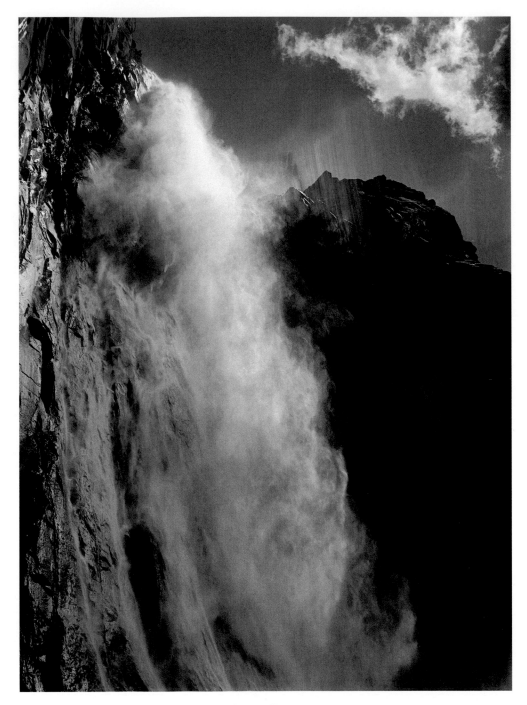

Ribbon Fall, c. 1940

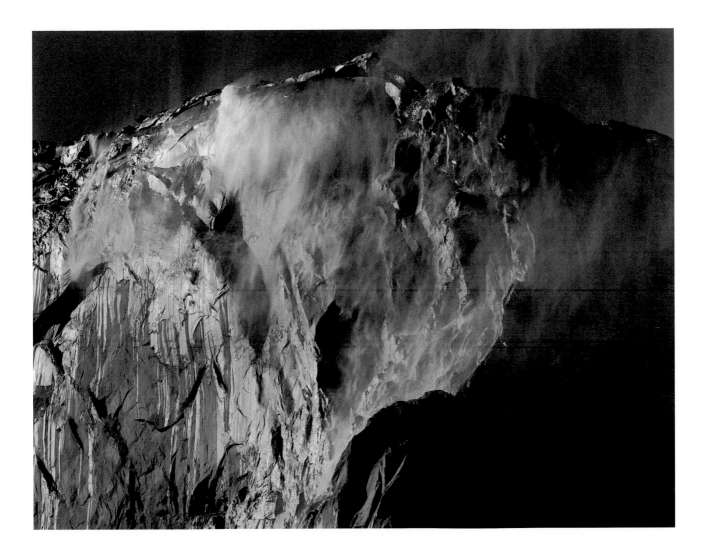

El Capitan Fall, c. 1940

With Yosemite,
we have one of the most extraordinary places on earth,
but Yosemite possesses a "fatal beauty" which invites self-destruction
unless we make a strenuous effort to control
visitation and use.

From a radio address, March 15, 1968

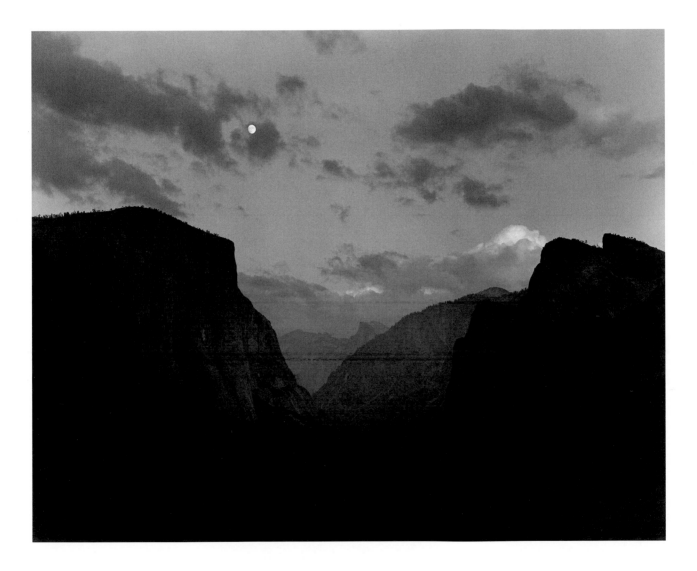

Yosemite Valley, Moonrise, 1944

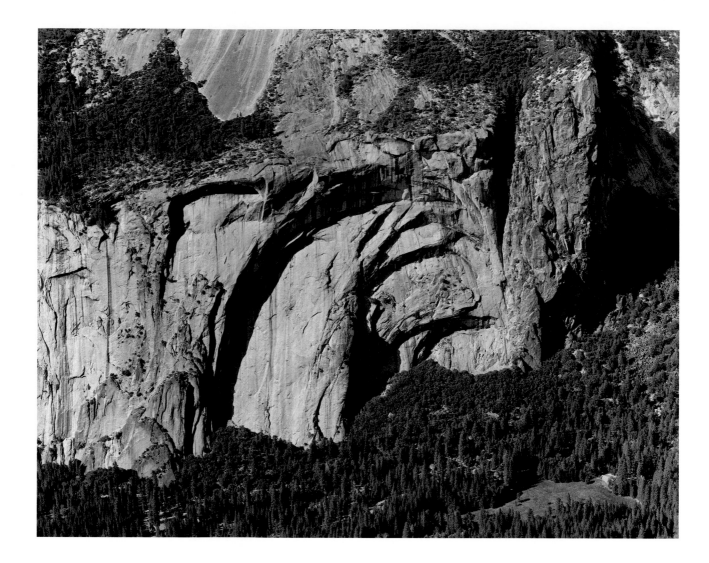

Royal Arches, Washington Column, and the Base of North Dome, c. 1940

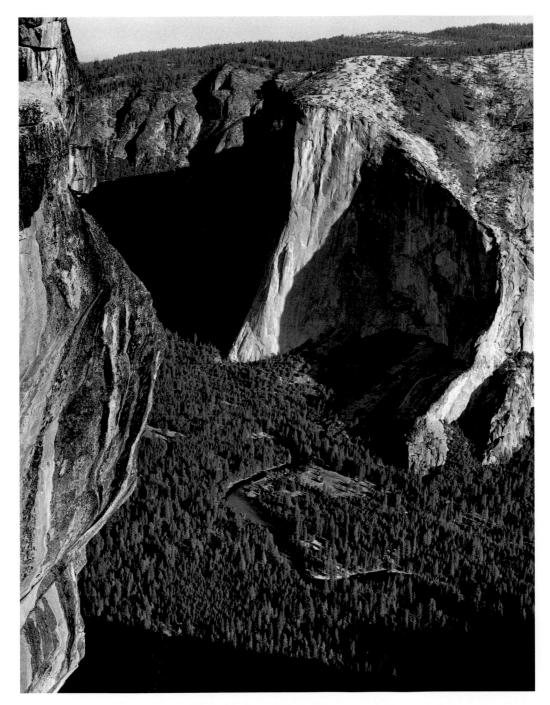

El Capitan from Taft Point, c. 1936

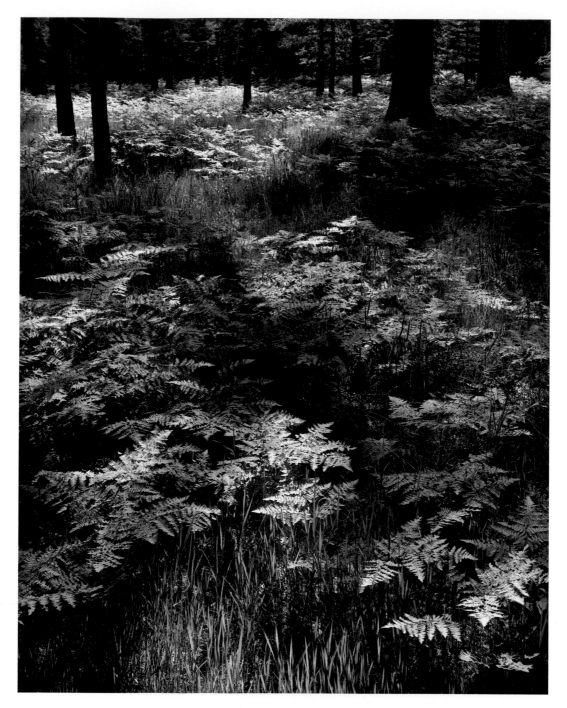

Ferns on the Floor of Yosemite Valley, 1948

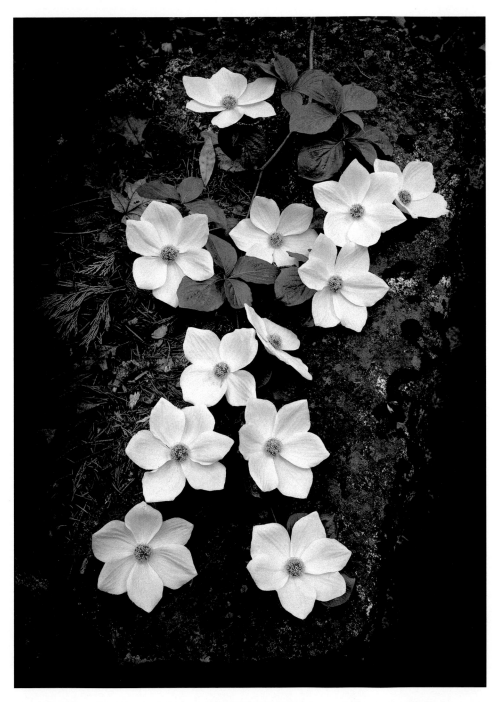

Dogwood, 1938

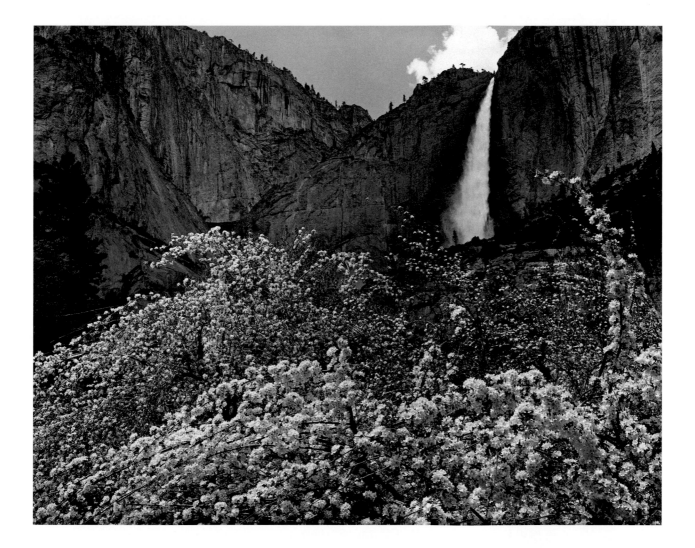

Yosemite Falls and Apple Blossoms, c. 1936

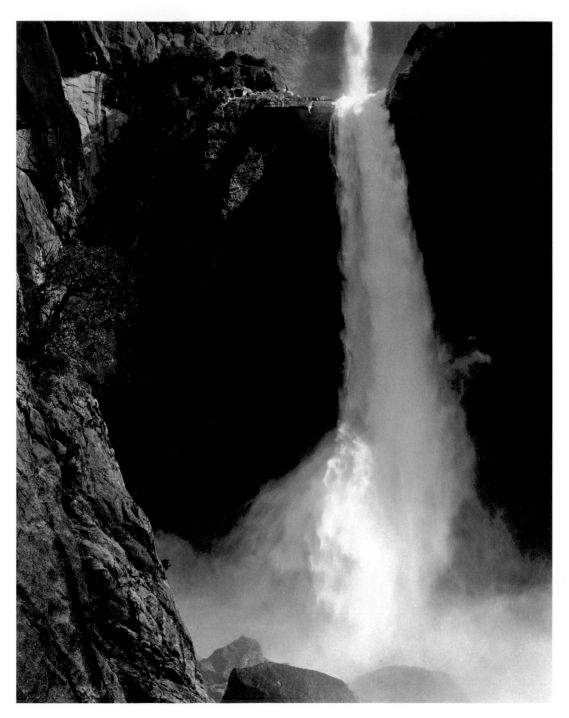

Lower Yosemite Fall, c. 1946

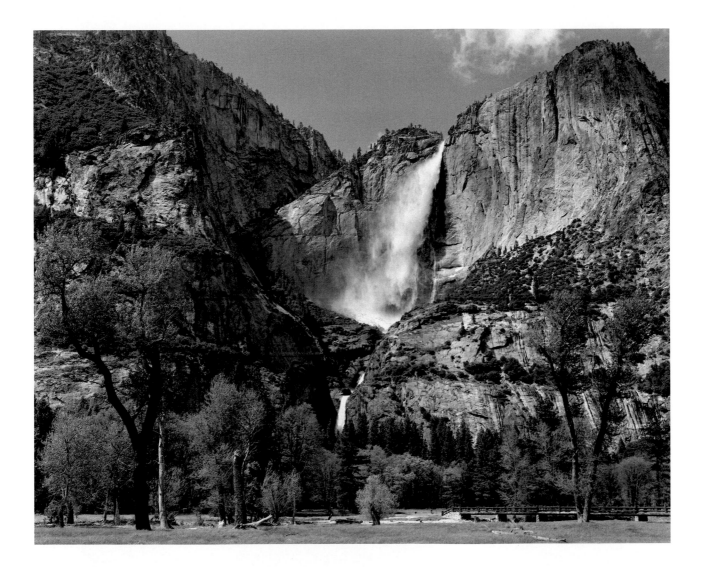

Yosemite Falls and Meadow, 1953

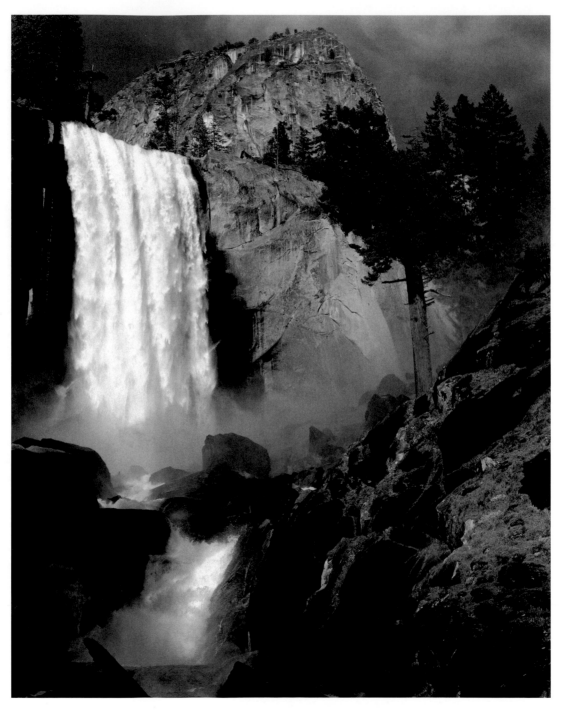

Vernal Fall, c. 1948

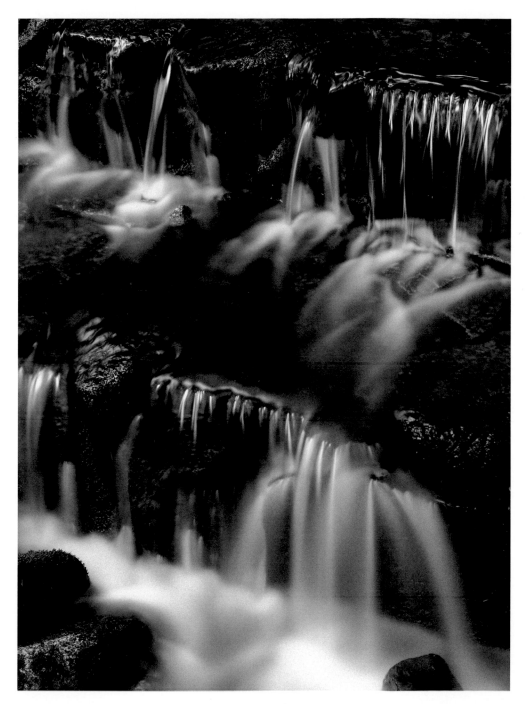

Fern Spring, Dusk, c. 1961

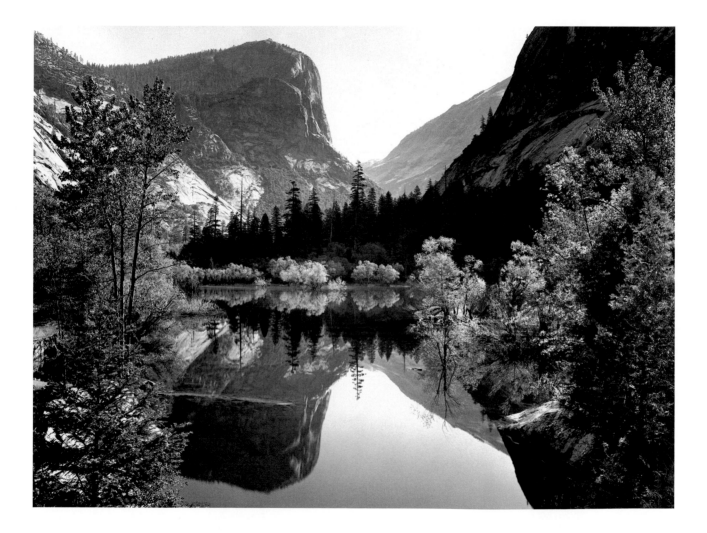

Mirror Lake, Mount Watkins, Spring, 1935

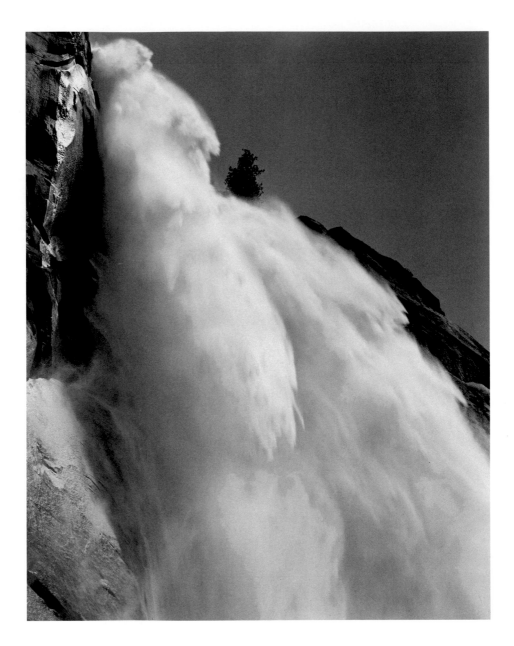

Nevada Fall, Profile, c. 1946

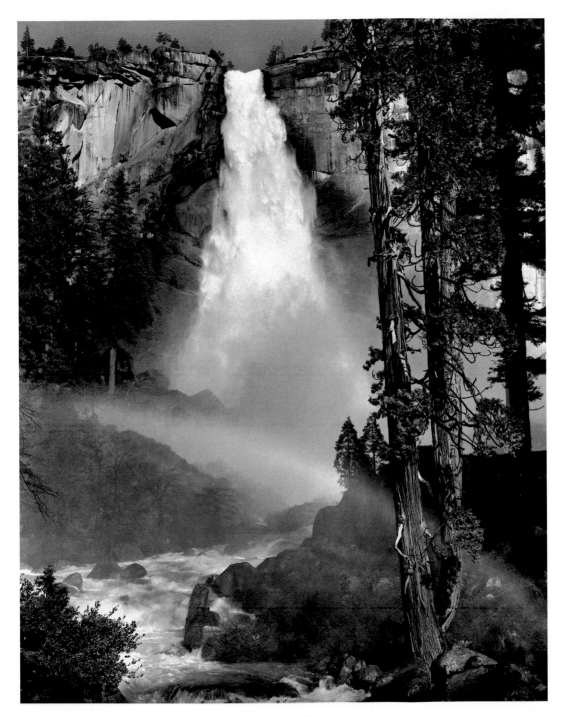

Nevada Fall, Rainbow, 1946

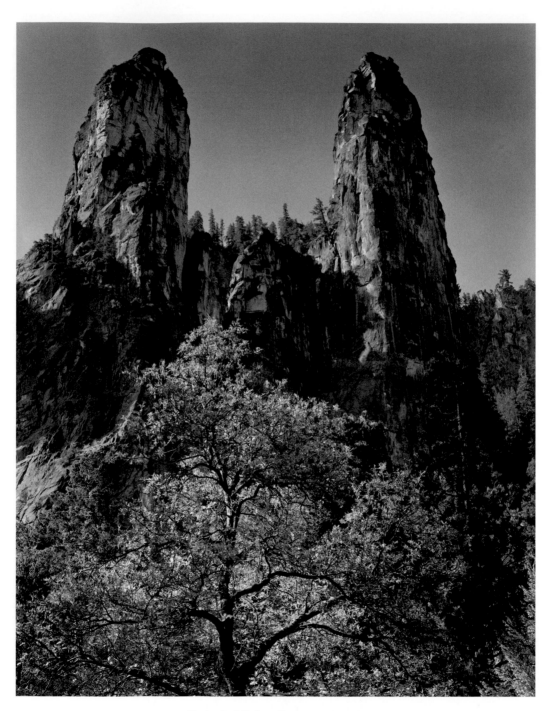

Cathedral Spires, Autumn, c. 1947

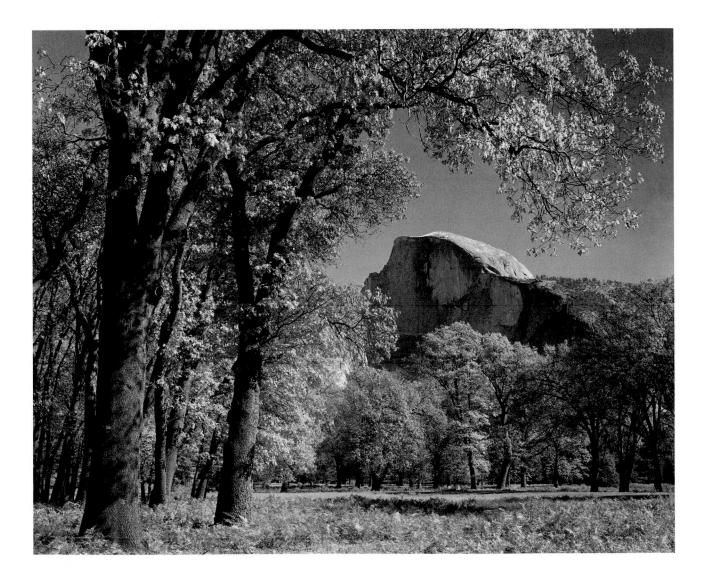

Half Dome, Autumn, 1938

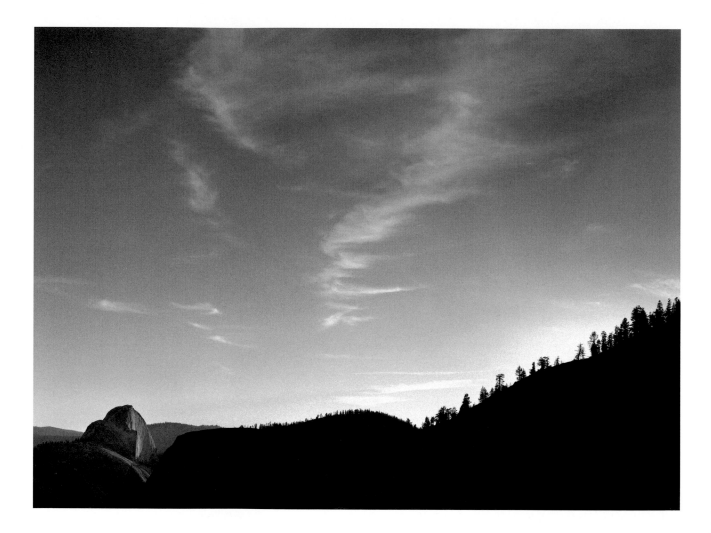

54 Half Dome, Evening, from Olmsted Point, c. 1959

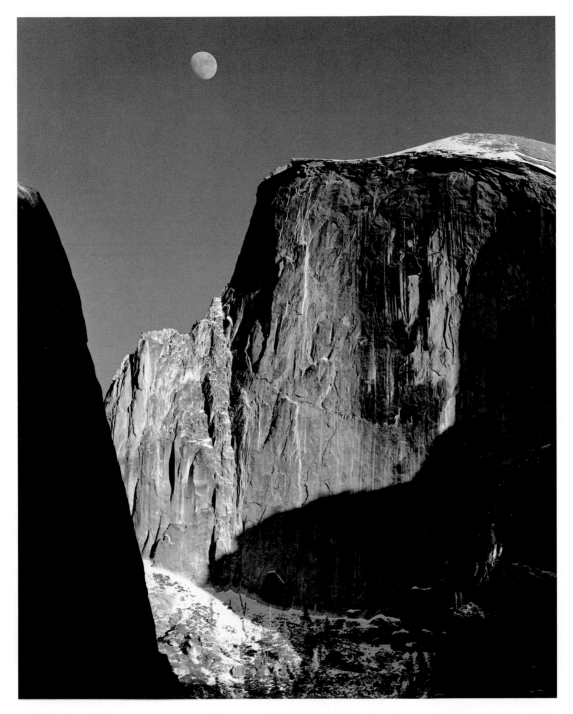

Moon and Half Dome, 1960

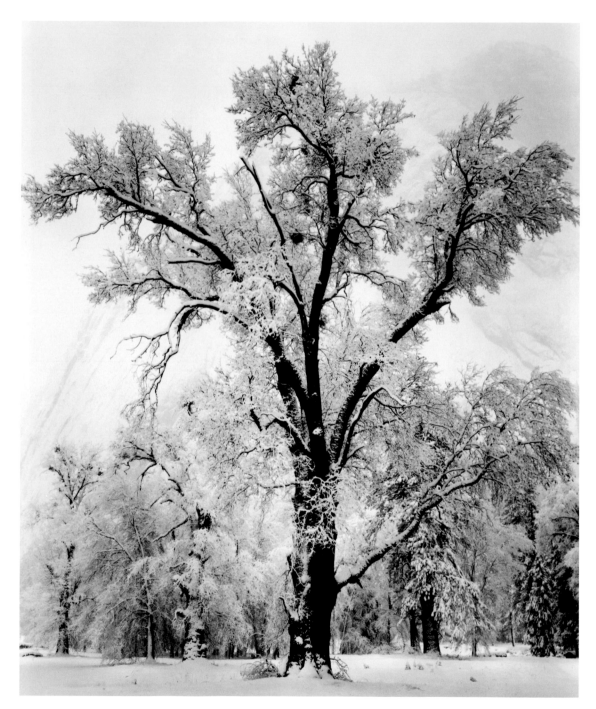

Oak Tree, Snowstorm, 1948

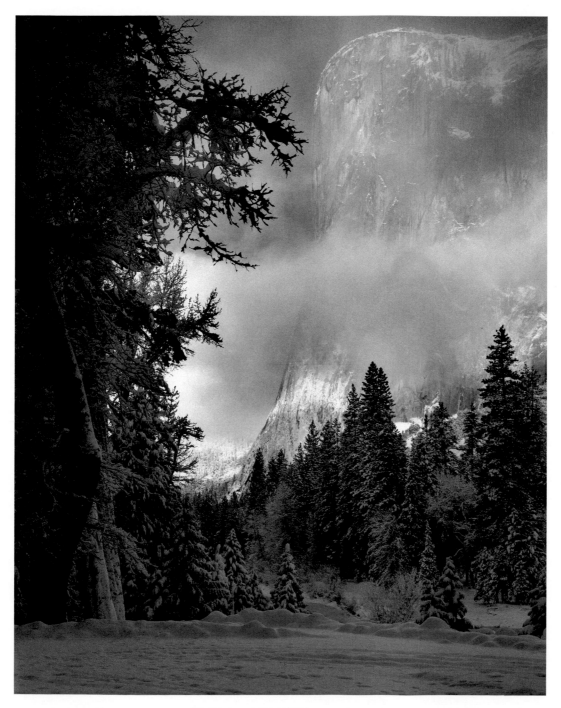

El Capitan, Winter, Sunrise, 1968

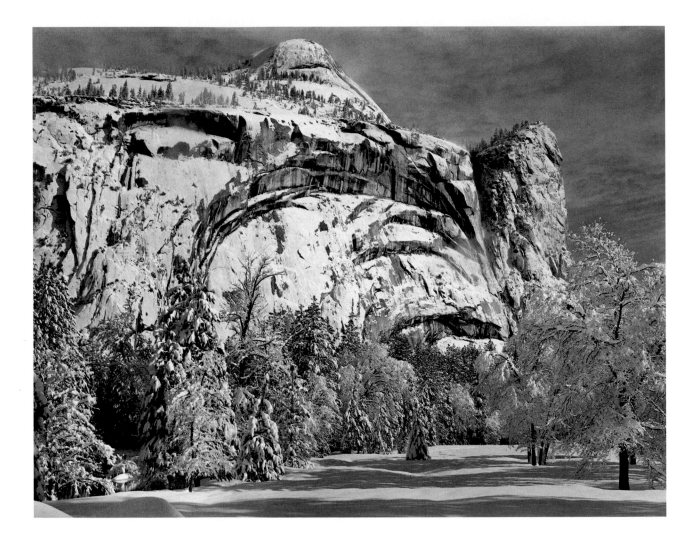

North Dome, Royal Arches, Washington Column, Winter, c. 1940

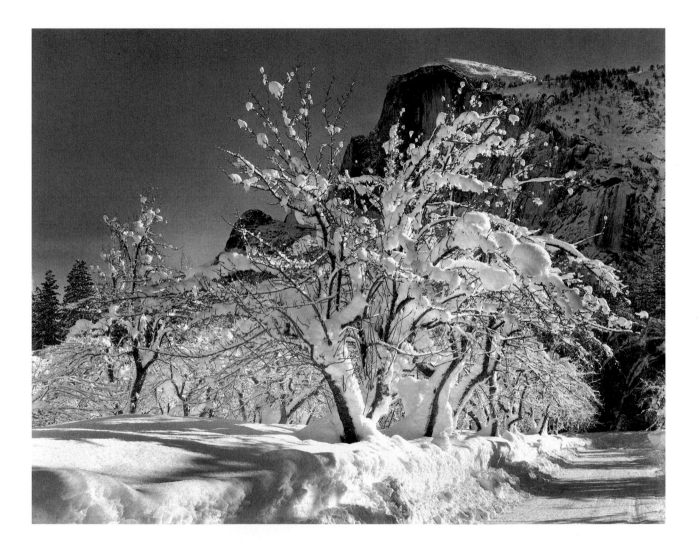

Half Dome, Apple Orchard, Winter, c. 1930

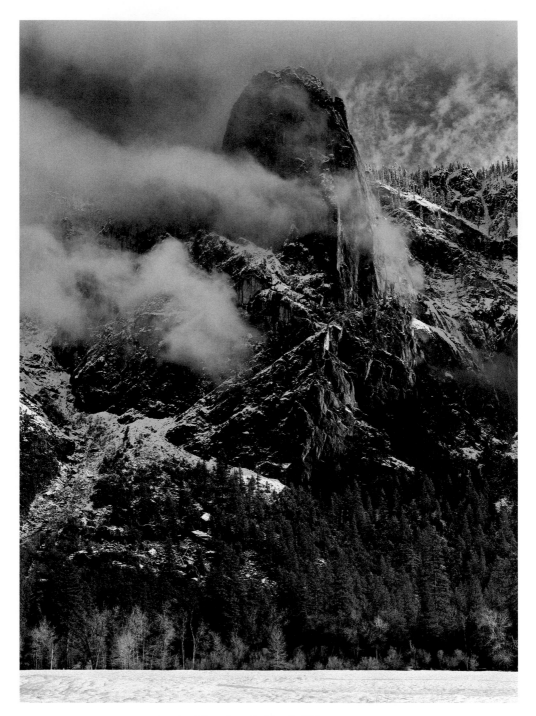

Sentinel Rock and Clouds, Winter, c. 1937

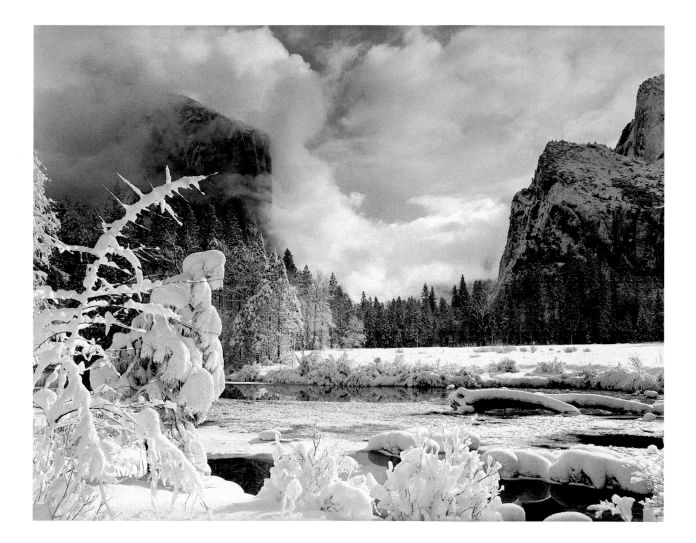

Gates of the Valley, Winter, c. 1938

No matter how sophisticated you may be,
a huge granite mountain cannot be denied—it speaks in silence
to the very core of your being.

From "Retrospect: Nineteen-Thirty-One," Sierra Club *Bulletin,* February 1932

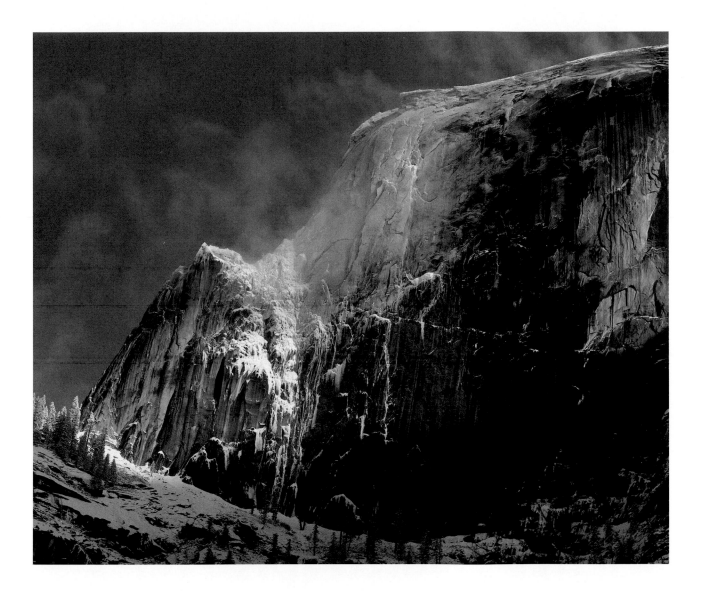

Half Dome, Blowing Snow, c. 1955

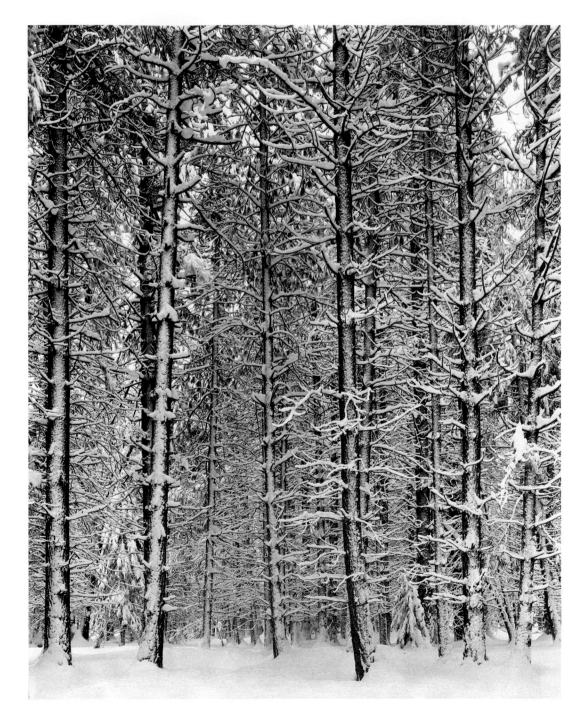

Pine Forest in Snow, 1933

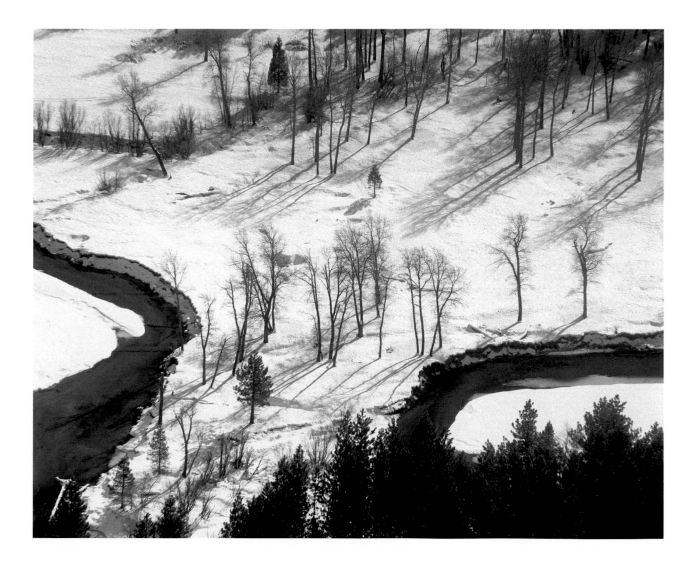

Merced River and Snow from Columbia Point, c. 1923

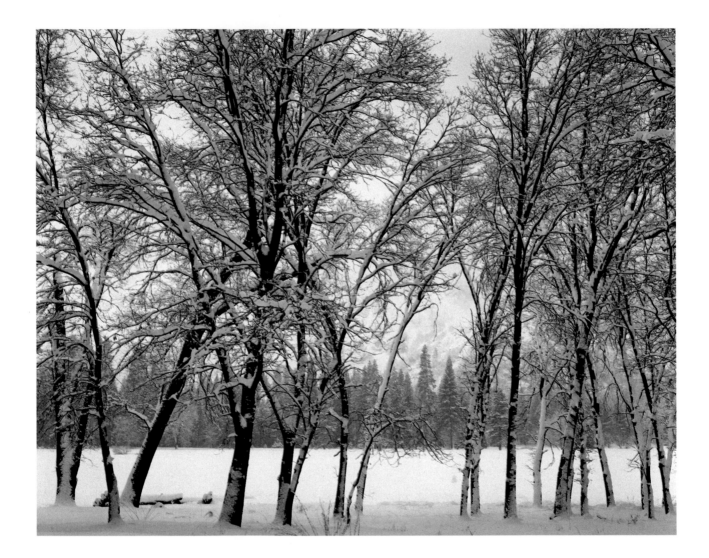

Young Oaks in Snow, c. 1938

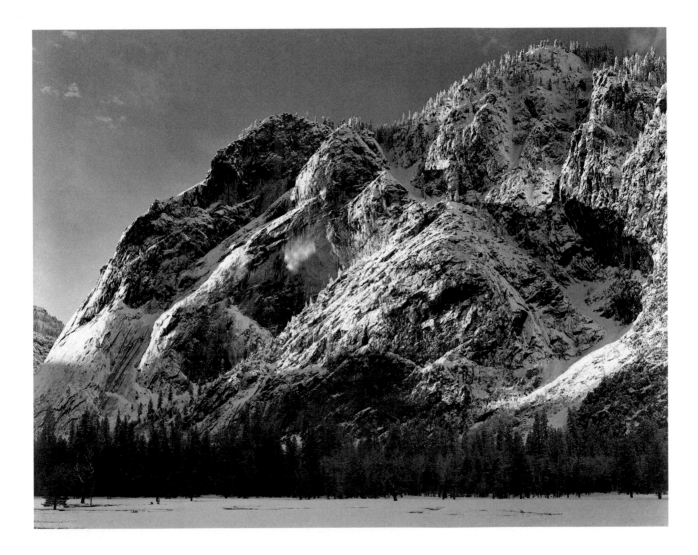

Cliffs of Glacier Point, Avalanche, c. 1939

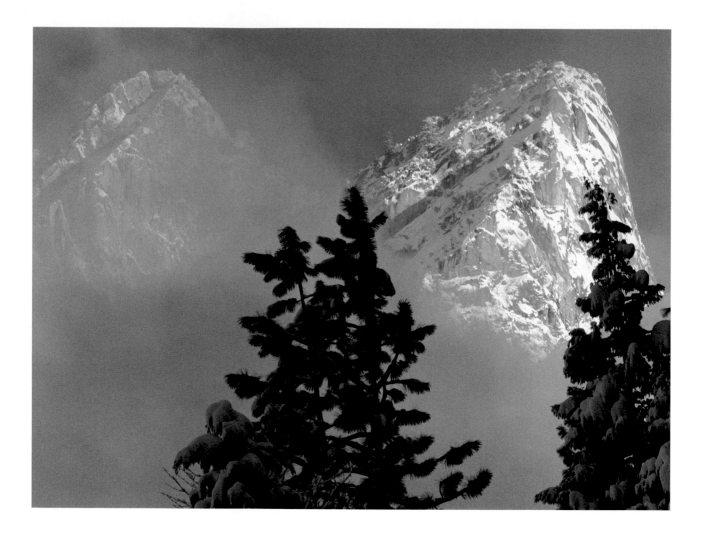

Eagle Peak and Middle Brother, Winter, c. 1960

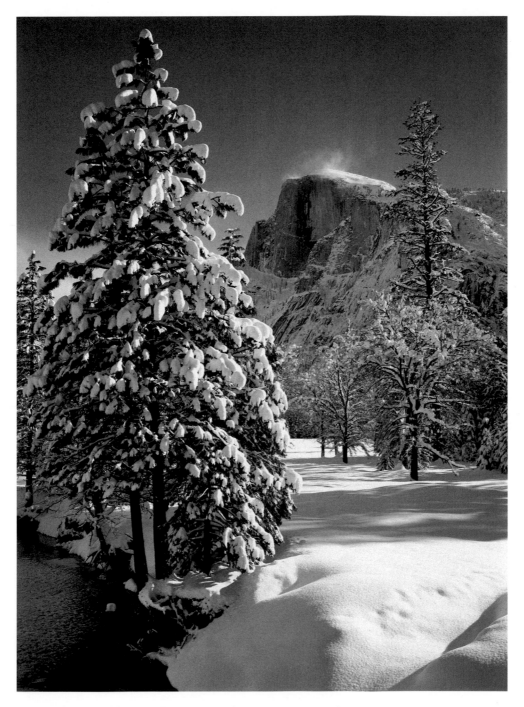

Half Dome, Tree, Winter, from Stoneman Bridge, c. 1940

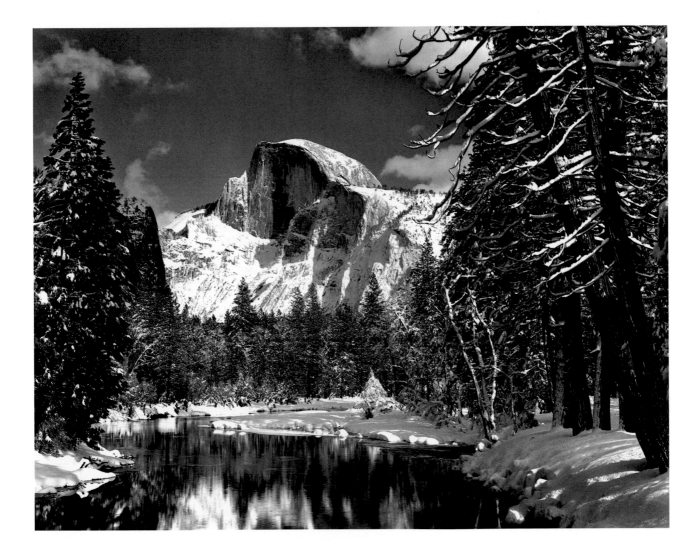

Half Dome, Merced River, Winter, 1938

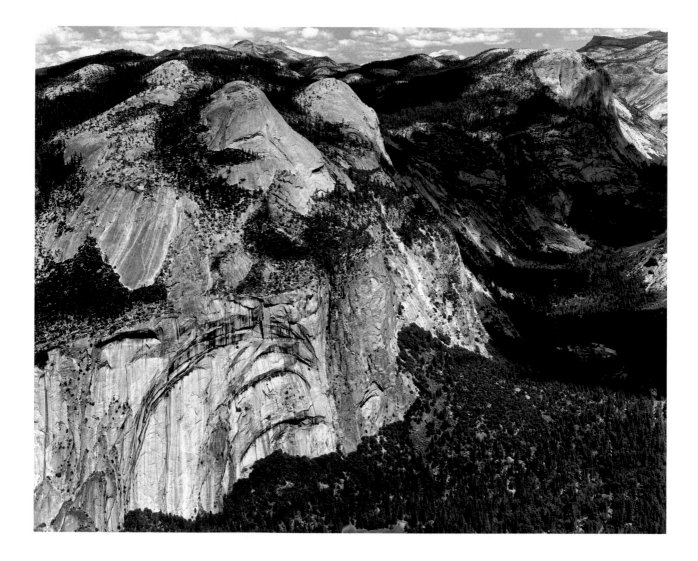

View up Tenaya Canyon, c. 1940

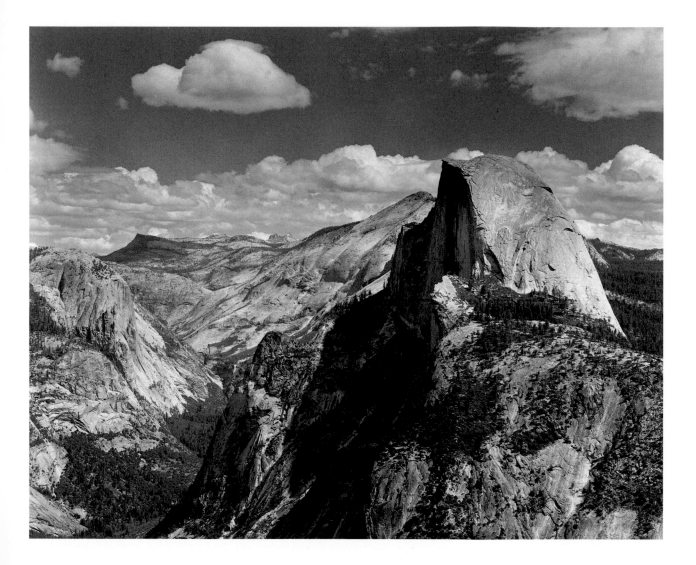

Half Dome and Clouds, c. 1968

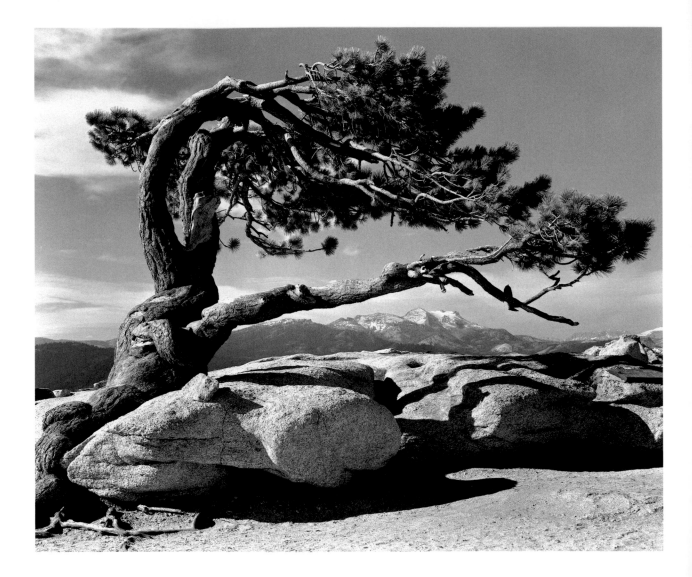

Jeffrey Pine, Sentinel Dome, 1940

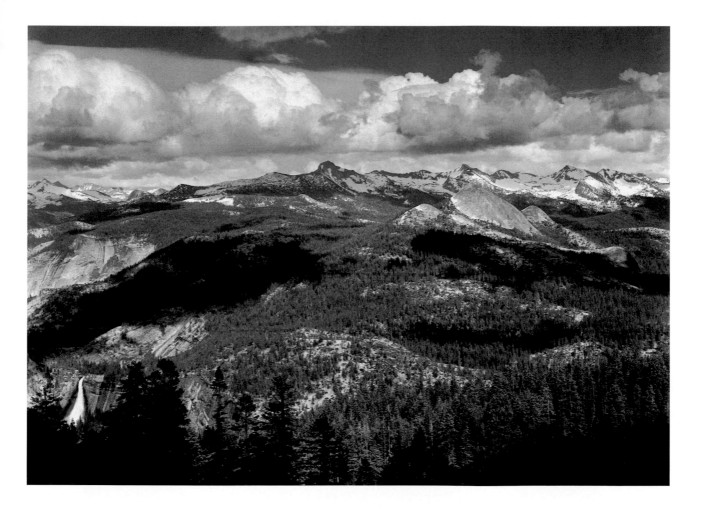

The High Sierra from Sentinel Dome, c. 1935

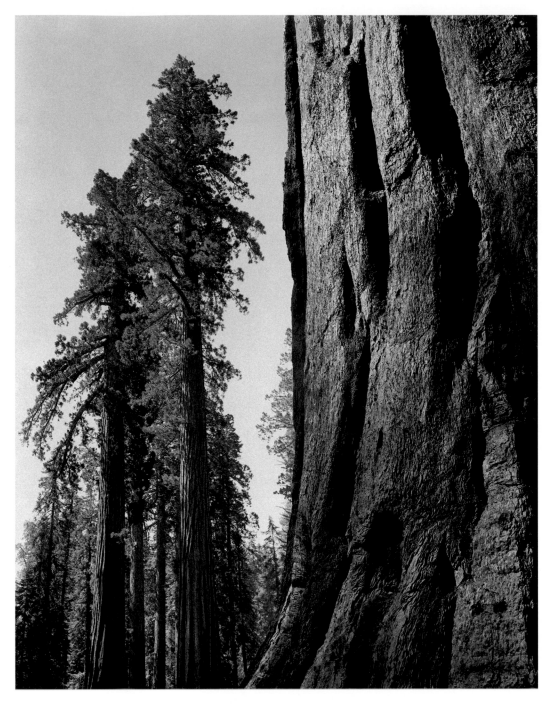

Giant Sequoias, c. 1944

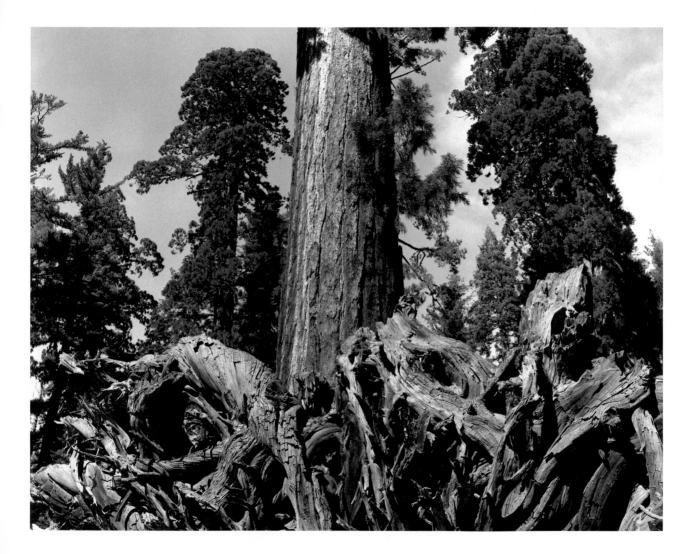

Redwood Roots and Tree, Mariposa Grove, 1944

It is difficult to explain the magic:
to lie in a small recess of the granite matrix of the Sierra
and watch the progress of dusk to night, the incredible brilliance of the stars,
the waning of the glittering sky into dawn,
and the following sunrise on the peaks and domes around me.
And always that cool dawn wind
that I believe to be the prime benediction of the Sierra.
These qualities to which I still deeply respond
were distilled into my pictures over the decades.
I *knew* my destiny when I first experienced Yosemite.

From *Ansel Adams: An Autobiography,* 1985

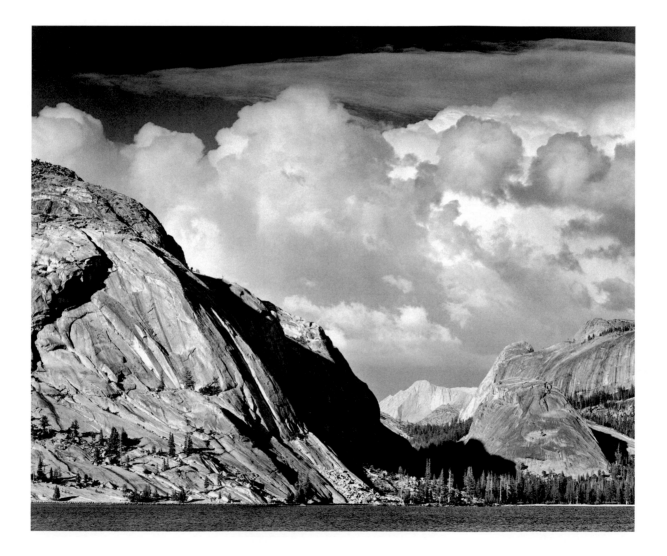

Tenaya Lake, Mount Conness, c. 1946

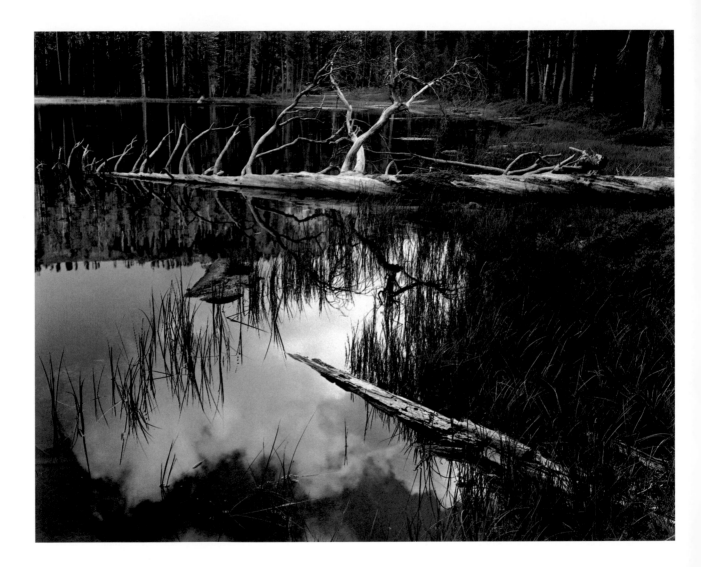

Siesta Lake, c. 1958

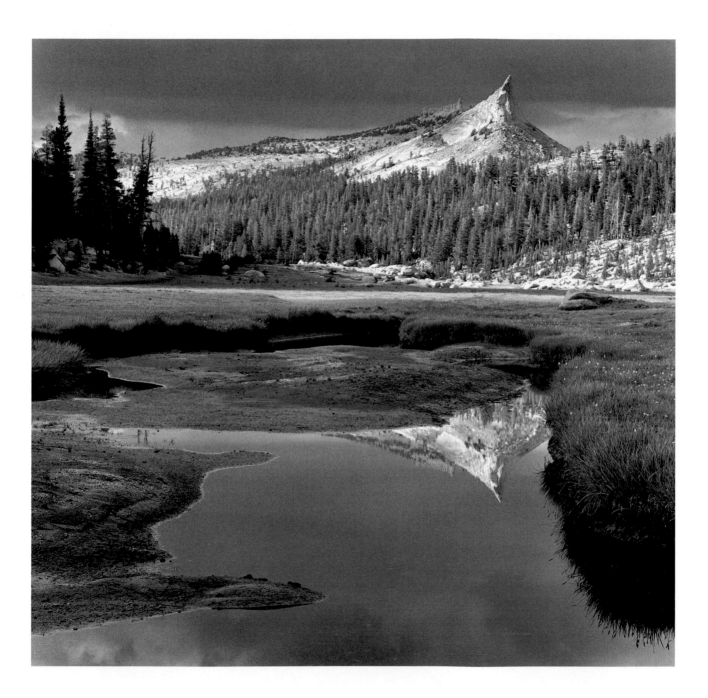

Columbia Finger, Pool, c. 1960

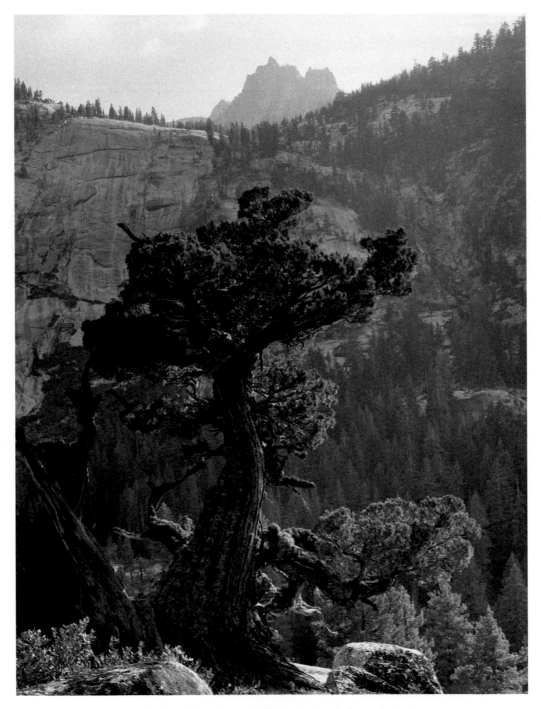

Juniper Tree, Crags under Mount Clark, c. 1936

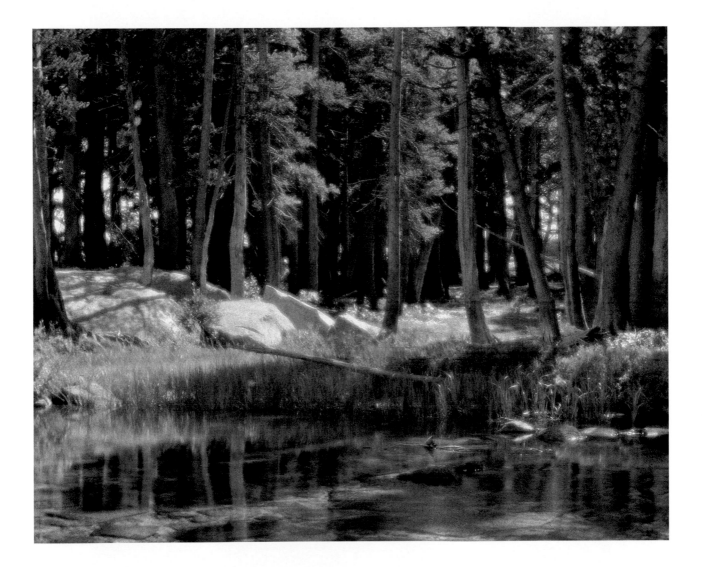

Lodgepole Pines, Lyell Fork of the Merced River, c. 1921

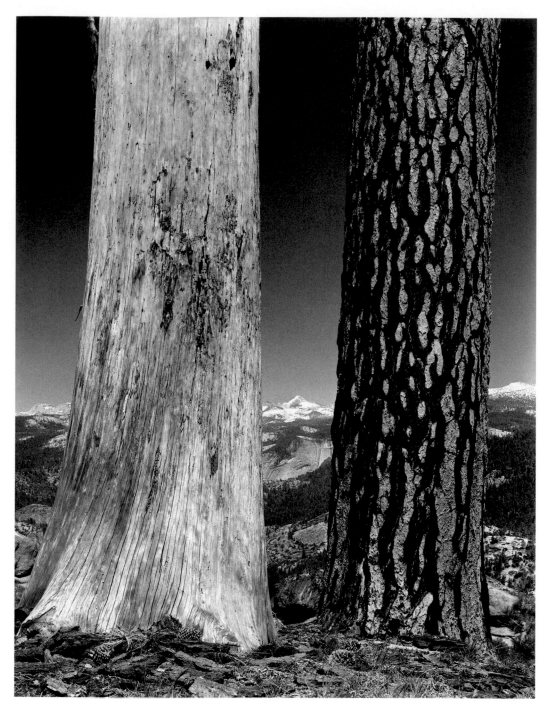

Trees, Illilouette Ridge, c. 1945

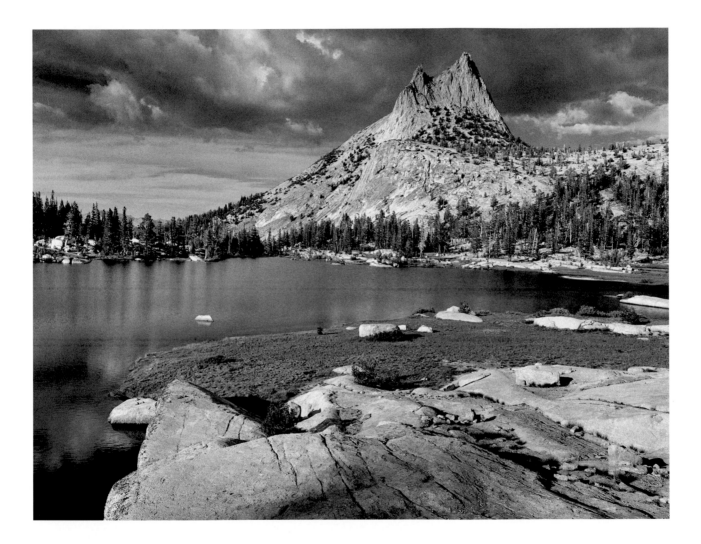

Cathedral Peak and Lake, c. 1960

Truly the "Range of Light," as John Muir defined it,
the Sierra Nevada rises to the sun as a vast
shining world of stone and snow and foaming waters,
mellowed by the forests growing upon it
and the clouds and storms that flow over it.

From the Foreword to *Sierra Nevada: The John Muir Trail,* 1938

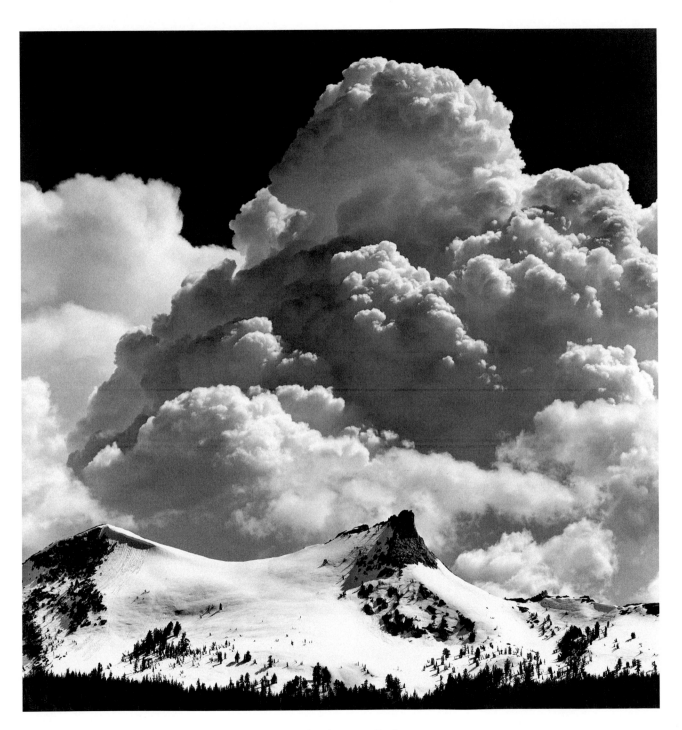

Thundercloud, Union Peak, 1967

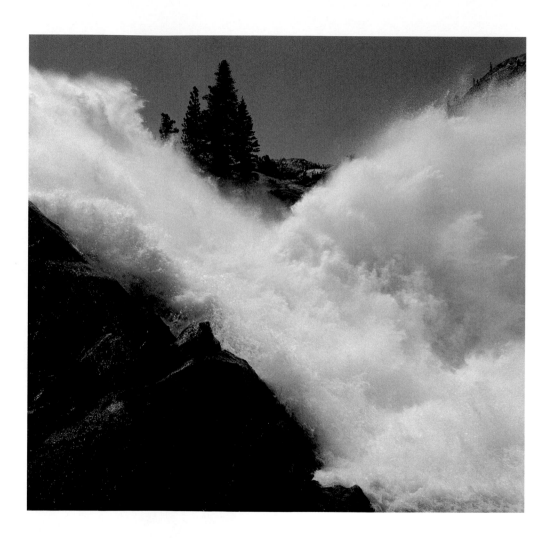

Waterwheel Falls, c. 1940

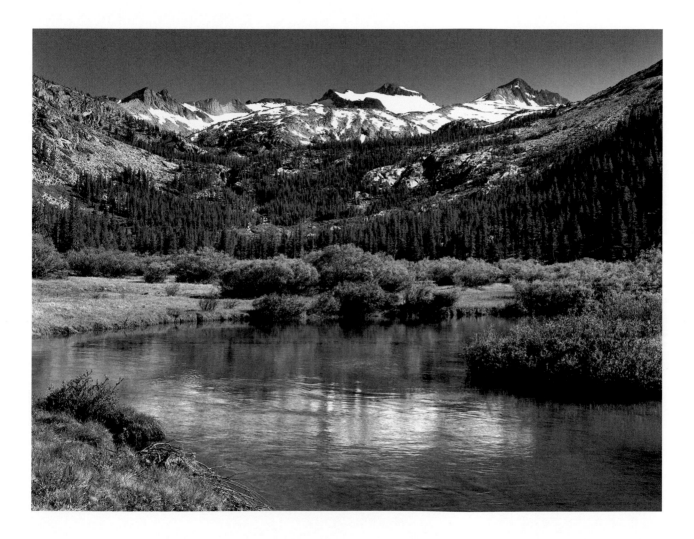

Mount Lyell and Mount Maclure, Tuolumne River, c. 1936

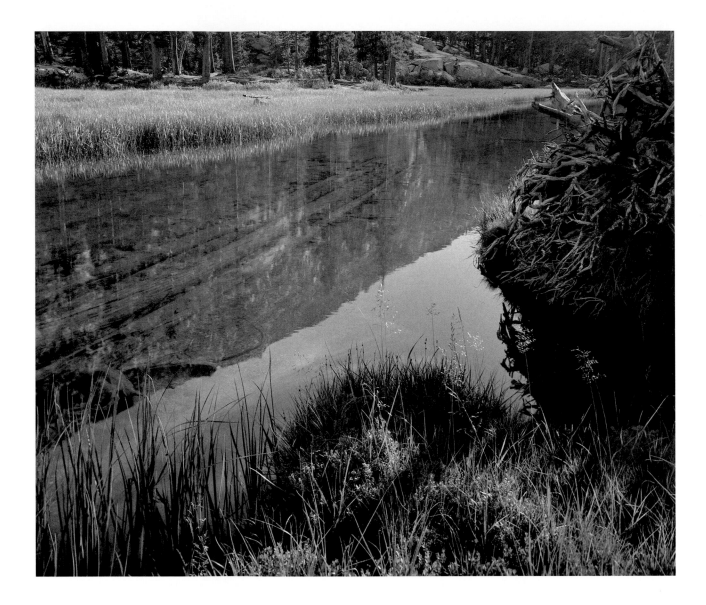

Meadow and Stream, Lyell Fork of the Merced River, c. 1943

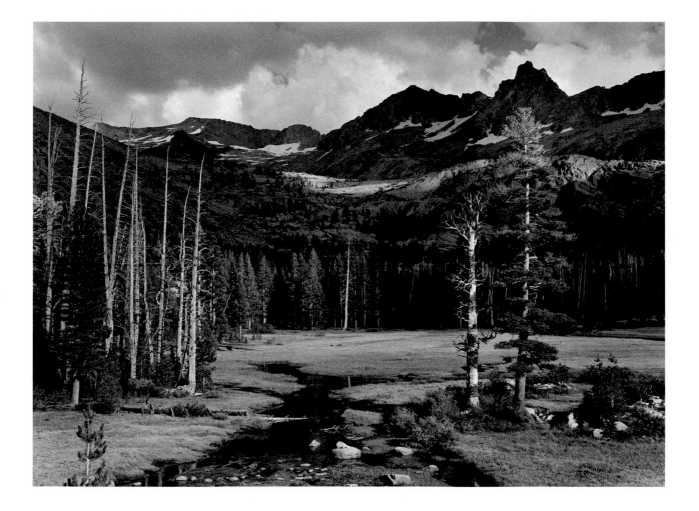

Mount Ansel Adams, Lyell Fork of the Merced River, c. 1935

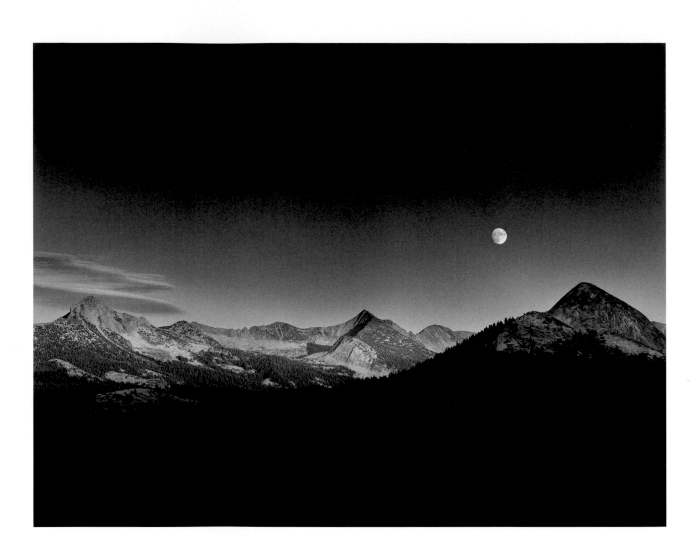

Autumn Moon, the High Sierra from Glacier Point, 1948

Selected Writings by Ansel Adams

The desire to get into the mountains has grown very strong in me lately and the Yosemite is so very wonderful. But the crowds—how often I wish that the Valley could be now like it was 40 years ago—pure wilderness, with only a wagon road through it, and no automobiles nor mobs nor auto runs "nor nothin'" disturbing. That is why I long for the high places—they are so clean and pure and untouched.

From a letter to Virginia Best, March 30, 1923

The picture here is amusing—if it were not tragic. Yosemite is one of the great gestures of the earth. It isn't that it is merely big—it is also beautiful, with a beauty that is as solid and apparent as the granite rock in which it is carved. The U.S. owns it and administers it; a public service, the Company [Yosemite Park and Curry Company] makes it possible for you and me to eat and sleep in it. This company, with the steam-roller momentum of Big Business, needs to "bring people" to it. In order to achieve this end, it proceeds to approach the people in typical resort style; the quality of Yosemite is completely forgotten in the competitive urge to get the best of its banal competitors in Los Angeles, Santa Cruz and other "vacation areas." It is just like jazzing up the "Poem D'Ecstase" of Scriabin—a little hot rhythm, and there you are.

From a letter to Alfred Stieglitz, November 12, 1937

I believe a philosophy of appreciation has taken root in the consciousness of the American people. Even though distorted by the false emphasis and exaggeration of commercial exploitation and advertising, the *facts* of our magnificent land are nevertheless slowly rising above the tides of confusion. Now as vulnerable as the first seedlings after rain, they may in time become firm elements of our national life—but only if we nourish them and expand the positive directions of their growth. The sum of our *response* is the sum of our experience of myriad minute actualities and forces; the sum of our *appreciation* lies in the mood and understanding that we bring to these intimate experiences.

One weakness in our appreciation of nature is the emphasis placed upon *scenery*, which in its exploited aspect is merely a gargantuan curio. Things are appreciated for size, unusuality, and

scarcity more than for their subtleties and emotional relationship to everyday life. Even some of the most sincere proponents of the National Parks speak of "the oldest living thing," or "the highest waterfall," or "the greatest collection of geysers in the world," unmindful that such extremes are merely coincidental and have little to do with true spiritual and emotional values. The moon rising beyond a great mountain establishes an emotional actuality which has nothing whatever to do with size, distance, or coincidence. Likewise, common grass growing against stone may be of more poignant beauty than an entire grove of sequoias in their most conventional "tourist" aspect....

The imposition of commercial "resortism" violates the true functions of the National Parks. Our expectations of the Parks are largely formed by the resort-colored interpretations of the travel folders; the pleasures of the day overshadow the eternal pageant; the great mountains and forests become mere backdrops for a shallow play. Pure physical recreation (which certainly works no harm if in appropriate balance) aside, the only value of most national park and wilderness areas is *the value of the intangibles.*

Every person would rise in indignation were he to observe careless destruction of marketable timber, flooding of mines, or poisoning of lakes and rivers. Any tragic waste of our national resources would arouse alarm and protest. But now let us pause and think—are not the intangibles of the natural world an integral part of our national resource? And are they not of incalculable importance to the development of our civilization and to the generations to follow us? Can we let them be wasted?

We must fight for *integrity of experience* as well as for the more obvious benefits of existence. We are confronted with a terrifying danger to the Parks and to the Wilderness, and to all that they represent in our culture and way of living. Predatory interests desiring to enlarge their rightful share of the natural resources clamor for additional exploitation and invasion of these preserved areas, and for the limitation—if not actual rescinding—of important new designations.

The huge and aggressive business known collectively as *Travel* is a more dangerous adversary than all the oil, lumber, cattle, and mining interests combined. The large and confused public further complicates the problem. Our object should be to define the character and appropriate use of all the regions known as "naturalistic" so that their values will remain unimpaired for generations. Controlled use certainly does not violate any fundamental precept of Democracy....

From "Problems of Interpretation of the Natural Scene," Sierra Club Bulletin, 1945

❦

The situation, in terms of planning and development of the national parks, is one heavily burdened with potential disaster. The mounting pressures of population and the steepening curves of exploitation of our national resources are reflected in the bureaucratic efforts of the National Park Service to "keep pace" in preparing the national parks for a huge pattern of use and occupancy in the near future.

Granted that population and exploitation are in the ascendancy, it is nevertheless painfully apparent that the National Park Service is thinking, planning and executing on a very obvious and short-sighted concept of true park and wilderness values. The very qualities they are pledged to protect and preserve are being ploughed under by a basic miscon-

ception of the term "use." They are apparently progressing on the assumption (supported by travel and resort influences) that people *must* be brought to the national parks and wild areas in enormous numbers, and that this mustering of the multitude in some way justifies the existence of the National Park Service.

In actuality, these great areas exist for those who desire to experience their inherent qualities; the amenities of urbanism, slick highways, resort attitudes and attractions, etc., are definitely not in key with the simplicities of wilderness and the incalculable spiritual and inspirational values they generate. In this frantic scramble to "manage" and develop the parks and the wild areas, they are sowing the seed of irrevocable destruction—not only to the landscape itself, but to the more precious moods and spiritual values it represents. As wilderness decreases, it demands increasing protection and increasing respect. This charge would be stoutly denied by sincere proponents of the present development approach; yet all one has to do is to observe the growing cancer in almost every area under consideration. In some areas the infection has not obviously yet appeared; in others a virtual necrosis has set in. But we must be fair and express our appreciation for what good has and is being done. Satisfactory present examples of adequate national park operations are: Glacier National Park, and Sequoia and Kings River [Canyon] National Parks. Here there seems to be a satisfactory balance between preservation and appropriate *use*. Big Bend National Park, parts of Olympic National Park and some other areas are apparently well-managed in most respects. I confess I do not know what is on the Mission 66 [a government program to increase tourism by automobile in the 1950s] drawing boards for these areas, but I trust they will be left severely alone!

Certain aspects of Yosemite and Yellowstone are appalling in their desecration of mood and wildness. Urbanization so that myriads of people can "see" these places (few people seem capable of thinking of the term "experience") has resulted in the near-destruction of their prime reason-for-being. One cannot argue on the proportionate areas of urbanization versus areas of wildness; as I have often said, a wart on the face of Venus does severe damage all out of proportion to the actual area covered!

Not only am I concerned with the failure of the Park Service to serve as proper custodian for the park and wild areas, but I am also gravely disturbed over the apparent inability of the conservation groups to come properly to grips with the problem and formulate clearly their objectives; also to apply constructive pressures with adequate force. There is too much internal obfuscation, too much spirit of compromise. Frankly, there is too much "consideration" for the opposition! We need to formulate the problem on a resolute basis and clearly present our views to the governmental agencies as well as to the public and the press—with all the force and sincere purpose consistent with a true dynamic democratic spirit. If the group will not speak for the individual, the individual must speak alone!

I urgently recommend:

1. An immediate moratorium for three to five years on all national park plans and developments—including those of Mission 66—and the cessation of work on all projects not definitely in construction at this time.

2. A special conference to explore the gravity of the situation and the need for a new definition—a truly protective one—of park and wilderness principles and objectives. This conference should be composed of a fresh selection of intellectual and social leaders—including advanced planners, archi-

tects, artists and scientists. It should not be a mere repetition of the endless meetings and conferences composed of the groups and individuals of the present conservation complex. We need a new and vital (and imaginative) concept of the national park and wilderness milieu. We are not going to achieve this by the dull repetitions of ancient and jaded "principles," or by the polite protestations which for so long have been largely ineffectual in influencing really basic matters.

In writing this letter to you I am also writing to my fellow citizens. As I enter what will be the last third of my life, I am deeply concerned over the possible loss of our priceless heritage. I have experienced at first hand the tremendous benefits of contact with many wild and beautiful places in our land—especially Yosemite—and I believe it to be a sacred obligation to work for the perpetuation of these benefits for the generations of Americans to come.

Draft of a letter to Frederick A. Seaton, Secretary of the Interior, c. 1956–60

☗

The problem of Yosemite cannot be discovered in any one manifestation of government or operator activity. It relates to an attitude of mind and heart, to humility and respect for the natural scene and its relation to humanity. When there was a vast reservoir of wilderness, when areas such as Yosemite were difficult of access, there was a different kind of visitor; he came primarily for the *experience of the place*, and he was willing to sacrifice certain comforts and undergo considerable difficulties to gain this experience. As the areas became accessible, as the comforts were increased, as the "services" became more general, the character of the visitor—

in the aggregate—changed. The operator system is one, understandably, related to the profit motive. The government made demands upon the operator to establish plant and services, and the operator—in order to keep going—had to expand his enterprise to pay his bills and make a modest return. In doing this, he spread his services, entertainments, etc., to cover a wide and often unjustified range of public interests. In other words, his operation (which should have always been kept at a modest "service" level) has become a "resort" enterprise to which people are attracted for other reasons than the simple experience of the natural scene. The government has aided and abetted this situation; not many years ago they fostered a high-pressure travel campaign—"Make Every Year a National Park Year" and so on. Not many of the individuals in the Park Service have the vision and imagination to grasp what is actually happening. (The Park Service as a whole is composed of men and women of integrity and dedication; but qualities such as these do not automatically imply an adequate resource of creative imagination and logical, detached thought).

One situation begets another—a rapidly ascending curve of exploitation and "development" has now brought Yosemite to the brink of disaster—and the insensitivity in evidence here threatens to spread to other parks. The problems and situations are developed from within—not from without—in terms of long-time comprehension and use. Developments in the national parks are more sharply tuned to the requirements of the average tourist—as a tourist—than to the nature and necessities of the areas themselves, and to their most important function in the domain of the intangibles. I see nothing to feel happy about when I read of millions to be spent in the parks; I am quite sure that only the *status quo* will benefit; I am aware of no great evidence of true understanding

or resolve to understand the meaning of the wilderness. I admit it is difficult for a man of good will to visualize other men as being quite callous to nature and to other men, but the conditions in the parks prove they are!...

I know it is a great experience to live overnight on the floor of Yosemite. But we cannot have our cake and eat it, too. Sympathetic as I am to such experience, I simply do not see how camping on the floor of the Valley can be long continued without hopelessly affecting its appearance and mood— and I believe these more important to the general visitor than to the relative few who might enjoy a night's sleeping out. Camping had to be eliminated from the groves of Big Trees for protective reasons. It is a hard decision to make. People, things, buildings, events, and evidence of occupation and use simply will have to go out of Yosemite if it is to function as a great inspirational natural shrine for all our people. That means me, you, hotels, stores, bars, shops—everything but the barest service necessities.

It is perhaps true that the statistical housecount in Yosemite has not grown much per summer night over recent years. But there is a difference between 1,000 people staying six days each and 6,000 people staying 1 day each! This, in addition to one-day travelers from the local state areas who do not stay overnight, but extensively use the Valley in a variety of ways. Compared to ten years ago, or twenty years ago, each visitor expresses a statistical lessening of interest in the trails and a greater interest in social activities and amusements. There are still many thousands of our people who believe in climbing and hiking, etc., but who are scared from Yosemite by the grim aspects of commercialism, government organization, obvious "planning," and a permeating urban mood.

I cannot give myself to the impersonal gestures of generosity in welcoming many millions to Yosemite per season, simply because there can be "room" made for them. There has to be some kind of logical selectivity imposed; the first move should be to remove all extraneous activities and services to areas well outside the Valley (and, hopefully, outside the park). With the mere shell of natural beauty remaining the visitation would drop sharply! But those who came would gain the deeper experience. The National Gallery of Art is pleased that its attendance has been so good—but the important fact is that the attendance is based solely on art and the basic attraction of art, and not on dances, bars, movies, nightly firefalls and vaudeville, swift roads, super-comfortable beds and adequate food, Coca-Cola stands, "dude" rides and atrocious curios. No, the National Gallery of Art belongs to the people and serves those who wish to attend for the purpose of getting experience in art. Why cannot the national parks be planned and operated along the same logical lines?

From a memorandum to David Brower, Executive Director of the Sierra Club, January 6, 1957

❦

I have often heard the statement that "only the eastern end of Yosemite Valley is fully developed— only 5% of the entire Yosemite National Park—so what is the argument all about? 95% of the Park is 'wilderness.'" This is as valid as the statement that a beautiful woman lost an eye, but that is nothing— only 5% of her whole corporeal surface! The entire Yosemite Valley is the supreme concentration of grandeur and beauty—and it is now as close to total destruction of mood and intangible beauty as it can get without being hopelessly lost to us. What is difficult to explain to people is the very obvious

fact that the values of Yosemite Valley cannot be measured in acres, tons of rock, board feet of lumber and gallons of water (plus a census of deer, bear and chipmunks)! The value of Yosemite exists only in its entirety-of-being, and its integrity of mood. One is now conscious of a vast *disrespect* for these qualities; many small intrusions of what is called "development" shatter the pristine whole of the Yosemite experience. And in terms of our democratic society, these intrusions approach criminal negligence! The majority is represented by the present crowds, but the minority also have rights....

From a letter to Elisabeth K. Thompson of Architectural Record, *February 7, 1957*

❦

Within my capacity for legal understanding (slight) I have attempted to take an objective view of the Wilderness Bill. Emotionally, I am strongly inclined toward any means to further protect the wild places. This bill—and other important legislation over the past decades—seems to represent a kind of National Conscience—it is difficult, if not impossible, for the layman to comprehend the legal and legislative complexities, but he can (and does) respond to the underlying motivations....

I came to Yosemite first in 1916 (was 14 years old). Until 1929–30 I was actively studying music—then turned to photography. My life has been largely concerned with the interpretive and expressive aspects, and I naturally have viewed the National Parks and the wilderness through the eyes of an artist rather than those of a scientist, politician, or administrator. I have been returned to the Board of Directors of the Sierra Club largely because of my "nuisance" value; certainly not because of any ability in legislative and political

fields! Over the years I have seen the material values and qualities of Yosemite "improve" and the emotional, "magical," and inspirational moods regress. This is very difficult to put into words; it is frankly related to the intangibles, and can only make sense in that domain.

I have always considered the prime objectives of the National Parks were to provide inspiration, self-discovery of spirit in the wild places, and appropriate recreation. The principal parks and monuments are set aside and protected for such human benefits—not for economic purposes. They are, in effect, vast areas devoted to the development of the spirit and for recreation in the true sense of the term. This concept places the National Parks at the highest level of an advanced civilization. With this concept as a guiding light, it is difficult to comprehend how exploitation and "development" of recent kind can be justified and it is unfortunate that the Service has become so large that it cannot dwell upon the prime problems—but must preserve its own operational momentums and *create* activities to keep afloat. What I am saying is, in effect, that the Service itself—its momentums, energies, political resources, and public relations—has become more important than what it was originally set up to serve—the parks and the park ideals and spirit. Everyone in the Service is trapped in the vast web-like machinery of operations, development, policy, and public contacts. With the best intentions the Service has, I believe, lost touch with the more subtle and fragile elements of its responsibility.

I am quite aware that there are vast legislative and operational problems which must be faced, that the increasing population pressures make the present more difficult than the past (and the future will be more difficult than the present). The parks belong to the people, but I believe it is the respon-

sibility of the Park Service to protect and administer the parks for the people in terms of basic park and wilderness values, and not approach their responsibilities on the basis of selling the Service and the parks to the nation....

I am always inclined to make comparison between the functions and administration of the National Parks and of the National Gallery of Art in Washington. Both are the property of the people of our country. The Gallery of Art exists as a most excellent depository and means of display of truly great works of art. It is there for all who *wish* to come. People are not sucked in by excessive publicity, or by extraneous activities and entertainment. Nobody is making any profit, prestige or material out of the National Gallery as far as I can judge. But many people and institutions are making profit out of the parks—operators, travel lines, peripheral business, etc.—and these exert pressures along the complex and typical pattern of influencing legislation, political and bureaucratic policy, and creating a public demand....

...I do not believe in exclusion of anyone from the parks. But I do believe in what might be termed "natural inclusion"—the audience which is automatically attracted to the parks because of their intrinsic values—not the imposed entertainment values, or the values which are stimulated and augmented by publicity....

That is why I support the Wilderness Bill, and why I would support ANY bill that would serve to add protection, reduce exploitation (by business OR government), and aid in securing some positive remnant of true wilderness. I appreciate the pressures which the Park and Forest Services constantly resist, and I am thankful that so many are resisted, but there may come a time when the pressures might well exceed in power all the resistance we can muster under the present setup. If any legisla-

tion would serve to aid in resisting such destructive pressures it would be supported by all sympathetic people....

You see, I still believe in the fairies of mood and simplicity. And I think we are straying far from the appropriate paths in our frantic "developments" of the few beautiful wild places remaining in our land....

From a letter to Horace Albright, Director of the National Park Service, July 11, 1957

❦

Man, as an individual, might be mostly honest—but in a group or organization he can avoid ethics, as the blame can always be shifted (almost always!) from one desk to another....

But we are missing the boat if we merely exchange opinions about people and groups. The bitter fact remains for all to see: Tenaya, Yosemite, etc., etc. I am perfectly frank in saying that—in relation to the integrity of Yosemite—I have no qualms at all about hurting people's feelings by opposing them. I think it would be fine if the Director and his office were thoroughly hurt and scared by an aroused public opinion; they are doing a *terrible* job and deserve what they will get. While we act as gentlemen they laugh at us and by-pass us whenever possible.... I can't sit by any longer and feel sorry for the NPS. I have been around them, intimately, for a long time. It seems to me that a chastened NPS (because of an aroused public indignation) would be the best possible thing for the Parks! I am sure we will have to make our choice soon; Parks or Park Service. I have made mine!

From a letter to Richard Leonard, member of the Board of Directors of the Sierra Club, April 16, 1958

I wish to lodge a most sincere and severe protest against the desecration of Tenaya Lake and the adjoining canyon in Yosemite National Park which is being perpetrated by the ruthless construction of the new Tioga Road for the National Park Service by the Bureau of Public Roads. The catastrophic damage is entirely unnecessary and violates the principles expressed in the National Park Organic Act of 1916 which is accepted by our people as the basis of protection of our magnificent natural scene for our time and for the time to come. I consider this desecration an act of disregard of these basic conservation principles which approach criminal negligence on the part of the bureaus concerned. I urgently request you issue an order of immediate cessation of work on the Tioga Road in the Tenaya Lake area until a truly competent group can study the problems and suggest ways and means of accomplishing completion of this project with minimum damage. I have never opposed appropriate improvement of the Tioga Road but in 40 years experience in national park and wilderness areas I have never witnessed such an insensitive disregard of prime national park values.

From a telegram to Frederick A. Seaton, Secretary of the Interior, Sinclair Weeks, Secretary of Commerce, and Conrad Wirth, Director of the National Park Service, July 7, 1958

You will recall that on Saturday, July 5th, I offered my resignation from the Board of Directors of the Sierra Club on the basis that (1) I disagreed with the policy of the Club in regard to what I feel an essential attitude of protest to the National Park Service on the ruthless destruction in the Tenaya Lake region by the new Tioga Road construction, and (2) that I intended to personally protest against what I consider fundamental wrongs, not only at Tenaya Lake, but as evidenced in the general emphasis on "development" and excessive construction in Yosemite Valley.

I cannot go along with the Sierra Club in their attitude of compromise and persuasion. The results of this attitude are tragically apparent in the Yosemite National Park.

Hence, I wish to submit to you herewith my formal resignation from the Board of Directors— reiterating my verbal statement to you on July 5th, 1958—as I do not want to be in the position of embarrassing the Sierra Club by my personal and different opinions and actions.

From a letter to Dr. Harold Bradley, President of the Sierra Club, July 12, 1958. Adams' resignation was declined.

What is a road in a national park for? Why do people visit a national park such as Yosemite? Is it to be assumed that the park exists merely for a high-speed *passing-through* rather than for appropriate and intimate experiences *within* the area? Granted, there are areas which can tolerate relatively "fast" roads (Crane Flat to White Wolf, for example); the particular area in question, Tenaya Lake and the canyon to the east, is such an intense and beautiful scenic region that any road is an intrusion. The road now being built is a desecration.

As I brought out at the Tenaya meeting, in areas such as the floor of Yosemite Valley, Tuolumne Meadows, and the Mariposa Grove of Big Trees, the

National Park Service has posted reduced speed signs in areas of congestion, construction, or where some dominant feature demands. Why could not the Service have designated the approximate three miles of road through the extraordinary Tenaya Lake region as being in an *intense scenic area*, and posted speeds of 20 to 25 miles per hour thereon? Had the road been designed appropriately for the area and for these reduced speeds, I am sure most of the tragic damage could have been avoided. I believe we must ask the public to cooperate in the protection of their priceless possessions!

The "you can't stop progress" excuse for such damaging construction simply does not hold water in relation to the national parks. The only progress admissible in the obligations of the National Park Service is that which tends to preserve, rather than to deface by over-development, the aspects and qualities of the natural scene.

I strongly believe it should be the policy of the National Park Service to resist rather than encourage "developments"; their job is largely protective and, I admit, a very difficult one as pressures for development accumulate from different directions. There is too much swivel-chair and drafting-board decision and not enough intimate observation on the ground! Trees will grow again, meadows and even stream-beds will re-form, but once the granite—the very bones of the earth—is cut into, the damage remains for all time. Aggressive engineering is out of place in a national park! Capable as many people in the Service are, I firmly believe that consultations with interested groups and individuals (including artists, planners and conservationists) should be mandatory with such serious projects as roads, and that every foot of the routes should be examined and evaluated with the thought and object of maximum protection and preservation of the natural scene.

We of the conservation groups must also share the blame for this tragedy; we should have been alert! What price the "genteel" advisory attitude? An inappropriate "development" has been imposed on a beautiful and sensitive area of a national park. Let us hope that the example of Tenaya will be so impressively publicized that such a calamity will never occur again in an important scenic or wild area.

From a letter to Alexander Hildebrand, member of the Board of Directors of the Sierra Club, July 19, 1958

❧

My absence from the Wilderness Conference was not entirely due to a strong antipathy to such gatherings—I have a bad "sprung" back and look like a fish hook; in fact, if you sharpened one end of me you could catch sharks!…

Seriously, I read the resolutions passed at the Wilderness Conference. I am impressed that nothing really new happened. The same good platitudes and expressions of noble purpose, etc.—but where are we really touching the people and exciting them? This is the great problem we have ahead, and unless we manage to accomplish it all our efforts will be useless.…

What is the prime purpose of wilderness preservation? I think it is mostly on the inspirational level. Conservationists as a whole—in spite of their strong personal feelings—are notoriously opaque in the expressive and esthetic domains. Someday I would like to see a conference directed to the people, in which the problems of interpretation on an esthetic and emotional level will be stressed. I just can't see the importance of national parks, etc., if they exist only on a physical, factual, and curiosity level! In fact, the entire Sierra should be one

great national park and Yellowstone broken up into a group of national monuments! But such is the power of curiosity that a witch with three eyes commands more attention than a beautiful Venus with only two!!

From a letter to Dr. Harold Bradley, President of the Sierra Club, March 24, 1959

❧

I do have a very strong feeling about signs, because I think there is some quality of magic in the out of doors which is lost if it is turned into too much of a museum mood. Not that the signs are not sometimes of great value in certain areas.... But I do think that as we pass true nature we should be brought out into it rather than find it "crystallized" as a fact that has been classified and labeled. This is very difficult to put into words. I completely agree with you that signs do help from an informational standpoint, but my question is as to whether the actual value of information is as important as the subtle quality and mood of the natural scene all by itself and as it is "discovered" by people. For example, the little lake to the south of Tioga Pass to my mind needs no designation whatsoever. In fact, informational designation in such a case simply intrudes on the very magical scene which can mean many things to many people....

I first came to Yosemite in 1916, and in retrospect I am aware of the steady development in favor of more tourists, more business, more comfort and more extraneous facilities. I think that you can only appreciate the significance of this growth if you examine it at, let us say, ten year intervals. What seemed to be a small and innocuous development very often turned into some very large and dominating enterprise. That is why now, whenever I see

something which I do not consider really necessary to the appropriate appreciation of the natural scene, I raise my voice in protest. I assure you this is not just to make a nuisance of myself but is based on very deep seated convictions.

From a letter to John Preston, Superintendent, Yosemite National Park, July 5, 1961

❧

The Fire Fall [a nightly bonfire that was pushed into the Valley from Glacier Point] legend of Yosemite Valley is perpetuated in every conceivable direction. Latest is the cover of Life [magazine]. This to me is one of those extraordinary lily-painting events which our people seem to love and demand. Since I first saw it in 1916 it has rankled as a grossly inappropriate exploitation and an unnecessary promotional trick.

Perhaps I am old fashioned. Perhaps we should have yellow dye continuously injected into the Niagara River and pink lights thrown on Old Faithful. Ah Wilderness!!!

From a letter to Stewart L. Udall, Secretary of the Interior, October 18, 1962

❧

I have just returned from an excursion to Tuolumne Meadows and to the Sunrise High Sierra Camp. I have written a letter to Superintendent John Preston of Yosemite National Park expressing my warmest appreciation of the condition of the high country in spite of relatively heavy use, and also of the style, quality and operation of the Sunrise Camp. It is remarkable that the beautiful areas along the Sunrise Trail seem as clean

and fresh as they did more than thirty years ago when I spent much time exploring the beautiful peaks, valleys and meadows of this superb region.

However, there was one highly disturbing factor: the almost constant noise of airplanes flying over the wilderness areas. In one morning I counted at least fifteen planes over the immediate area. Many others were heard in the distance. And contrails were much in evidence in every direction.

I know that we are living in the air age and that it would be futile to think we could eliminate these disturbing sounds and contrails entirely. But I think some controls are in order to minimize the noise and intrusions in wilderness areas....

The large airliners seem to be the least bothersome; they fly high and their sound is remote. I saw only one helicopter and only a few small planes. The worst offenders are the military jets which fly low and fast and create a distressingly large amount of noise. Such noise certainly takes the edge off the wilderness mood and probably disturbs wildlife as well.

I can see no reason why these jets (apparently both Air Force and Navy) have to exercise over the wilderness areas and at relatively low altitudes. They should be prohibited from flying over the national parks and the wild areas. Certain routes across the Sierra—north of Lake Tahoe and south of Mount Whitney—could be designated, with perhaps a narrow corridor across Minaret Summit. I do not know just what the "sound zone" would be in miles, but I do not think it would be difficult to define the borders of a restricted area in the Sierra over which only emergency flights would be permitted.

Of course this same principle should be applied to all wilderness areas in the country. I have experienced this distraction in many areas, and I can

assure you that thousands of people agree with me that something should be done. Preserving the wilderness in the physical sense is not enough; we must also preserve the moods of quietness and of non-mechanical existence for which we turn to the beautiful wild places which remain for our enjoyment and spiritual enrichment.

From a letter to Stewart L. Udall, Secretary of the Interior, August 8, 1964

❦

It would be presumptuous to assert that I had a "plan" for Yosemite. After more than fifty years' association with Yosemite and the Sierra Nevada I have developed some ideas which I believe are logical and applicable. An expert planning team is now working on the problem. I speak only as an individual.

The seriousness of the problem is evident to all who visit Yosemite Valley in the summer season. We suffer from a semantic confusion; Yosemite is an area for re-creation, not just for recreation. We believe Yosemite to be a place of surpassing beauty, which should be available to all for maximum *appropriate* use. The term "appropriate" is a difficult one. We can compare Yosemite with a great musical performance. We can fill all the seats and perhaps sell some standing room without destroying the quality of what we experience. But we cannot sell lap room; in other words, we cannot permit a greater attendance than the event justifies for its own quality protection.

When more than 60,000 people visit the Valley in a single weekend (representing around 10,000 automobiles) the place is physically damaged, the mood is destroyed, and the people are not receiving

maximum and appropriate benefit from their visit. While exercising their "rights," they are damaging their own heritage.

We have forgotten, in part, the importance of the "wilderness mystique," the intangible qualities of the natural scene and the benefits of quietness and solitude. We are always after some fun expression and impose this wherever we may be. With Yosemite, we have one of the most extraordinary places on earth, but Yosemite possesses a "fatal beauty" which invites self-destruction unless we make a strenuous effort to control visitation and use.

Parking automobiles outside the Valley (admittedly not a simple project) and using buses for access, as well as "elephant trains" for circulation around the Valley, would, of course, reduce congestion, fumes, noise and the destruction of the natural moods. The number of campsites will have to be severely reduced, and the burning of campfire wood eliminated. Events and entertainment which attract people for their own qualities must be curtailed. Yosemite Valley must be used as originally intended: a preserve of vast natural beauty and wonder. Those who desire conventional recreation may discover it in many areas of less imposing natural values....

Unless we plan and act with determination we may well destroy what qualities of the natural scene remain for us and for the future populations of the world.

From a radio address, March 15, 1968

❦

Aₗₐᵣₘ!!!!

I read in this morning's S.F. Examiner and Chronicle, page 3, that snowmobiles are to be permitted on the Glacier Point Road and the Tioga Road in Yosemite National Park. There are certain requirements, such as, two must go together, skis and spare parts be carried, etc. BUT—

This is a major invasion of wilderness and we all must take immediate and forceful action to have the permission for snowmobiles in wilderness parks prohibited.

...To turn loose any number of private snowmobiles in the upper regions of Yosemite National Park could be a disaster. There would be no assurance they would stay on the roads. Winter mountaineers and cross country skiers would be properly offended by noise and fumes. And a most serious precedent will be established. Let us take action—most vigorously—without delay.

From a letter to Richard Leonard, member of the Board of Directors of the Sierra Club, January 25, 1970

❦

I have just had the privilege of attending a very important ceremony in Yosemite Valley—that related to the closing of the roads in the upper (east) end of the Valley to all motorized vehicles (excepting buses, service and emergency cars). The Director of the National Park Service, George Hartzog, Park Superintendent Hadley and others vitally concerned with Yosemite participated.

This is a milestone in the history of the national parks. It reverses the mechanistic trend and returns invaluable forest and wild land to the simple appreciation through walking, riding, bicycling, or traveling on the *free* shuttle buses. The favorable change of quality and mood on the first day is apparent to all visitors. Erroneous news to the effect that *all*

automobiles are excluded from the entire Valley caused some concern. However, this new plan points the way to the time when all cars will be excluded (but this will require extensive "staging" developments in the areas west of the Valley and outside the park).

…The principle involved is: exclude cars, but invite people! I believe it is a great step forward!

From a letter to the editor of the Monterey Peninsula Herald, *July 10, 1970*

❧

Thank you for sending me a copy of the Stanford Research Institute report on the concessioner situation in the national parks. I have gone through it with some attention to detail; although I am not a statistician, I can arrive at some concept of what the report relates to.

I am frankly perplexed at the "tunnel vision" represented. There seems to be no consideration of the meaning of the national park concept; no expression of opinion on the problems of preservation versus use. There is no apparent appraisal of degrees of interest in the natural environment; no evaluation of the elements of recreation and "re-creation" or the reasons why people visit parks. The report seems to be a purely business-operational questionnaire, intended to buttress the status quo and support only the concessioner viewpoint.

I think we all know what Yosemite is but not many are capable of verbalizing on its *meaning* for people in terms of experience as well as in terms of what we may call the "spiritual" elements of man's relationship to the natural world.

Freely admitting that Yosemite Valley is an impressive national shrine and must therefore be accessible to as many citizens as can be accepted without damage to the environment, I do not believe it necessary to increase facilities—or to maintain the status quo. We have made great strides towards elimination of the private automobile; the bus system is an impressive solution to the ever-growing traffic problem of recent years. When adequate "staging centers" are established, shuttle bus transportation will create a new spirit in Yosemite. Gradual removal of various services, offices, garages, warehouses, etc., and the reduction of overnight facilities and camp sites will further perfect the situation of both occupancy and enjoyment. Appropriate services should remain—but reduced, rather than expanded. Quality of food and lodging should be good throughout but consistent with the spirit of the environment. Unrelated recreational and entertainment activities (the hang gliders, for example) should be abandoned. I have always been in favor of the appropriate encouragement of art and fine music, as there is a certain resonance between the emotional response to nature and to creative art. This is a matter of policy rather than regulation; we cannot legalize good taste!

I believe it essential that logical wilderness restrictions be placed on other areas of the park. To me, this means minimum retention of "culture" (as noted on maps), roads, structures, etc., as well as imposed activities. There should be a reasonable emphasis on hiking, back packing and mountaineering, art and interpretive studies, etc.

Nowhere in this report do I find evidence of consideration of the essential values. I can assume that the answers to the questions posed are sincere and honestly recorded. But they do not relate to the basic principles and problems involved.

From a letter to Edward G. Hardy of the Yosemite Park and Curry Company, March 19, 1976

I have no love for MCA [Music Corporation of America] (and I had no love for prior concessioners!), but, since the founding of the National Park Service there has been a *de facto* relationship of "business" to the parks. [Stephen] Mather invited business into the parks with naive confidence that business would do a good job, keep park ideals in mind, and make a small, fair profit. He was a fine, trusting and rich man. He made a great contribution through the national park concept.

It soon became apparent (I would say around 1925–6) that any business in the national parks would have to protect its interest by expansion and provision of "amenities." Investments demand profits. Unless we have charitable and tax-loss motives as basic policy, any business must make money or go bust. The concessioner industry, with quite logical motivation, deemed themselves essential to the functions of the parks in relation to the people. In their eyes, "public service" (the profit variety) became an abiding obligation. And this obligation was nurtured by the National Park Service over many decades. Obviously the Park Service had no other answer to the problem.... The parks were there; people came to them; people had to be housed and fed (and sold horrid curios) and "entertained." (The natural scene was not enough, of course; the evenings were bleak — "gotta keep full of fun, man!!")

With VERY few exceptions the Park Service was populated with good, dull public servants without imaginative force (and little opportunity to express it if they had it). However, the Park people (with the conservation organizations mostly back of them in principle) did try to carry out the prime mandate. But time and again (and I saw a lot of this in the 1930s, 1940s and 1950s) the concessioner would go over the heads of the Superintendents and the regional people directly to the Secretary of the Interior (if the Director failed them) and on to Congress. And they usually got what they wanted. Such is the structure of American government.

Yosemite was fortunate because the Curry-Tressider family had fairly good taste and conscience. But they were trapped with the stockholders' demands for more tangible profit and also for the need for personal satisfaction of ego-accomplishment. Under Tressider, Yosemite was a benign feudal domain. If he had been a tasteless opportunist God knows what would have happened!...

What I am trying to say is this: the concession situation was initiated *by* the Park Service and has been continued by them and with demands upon concessioners for public service that created their commercial emphasis as a matter of survival. I do not forgive the selfish and stupid attitudes so often encountered with the concessioners. But I do feel that they function at a basic disadvantage and, to be completely fair, I do not think we can overlook this. In truth, if we do overlook it, we are not giving the accurate picture of the whole situation.

The National Park Service really must take the blame for the situation as we now have it.... Without forgiving the acquisitiveness of concessioners, I think we weaken our position by putting the entire blame on them. As a business man, in the position of a concessioner, would you not expect to "influence" a Master Plan to your advantage? Believe me, it has been done many times! The NPS has no power to refute this influence. I think that any Director of the NPS (except one functioning under a Secretary of the Interior such as Harold Ickes) would be powerless. It would mean a drastic change of basic policy (and one that would be resisted in Congress).

Hence, to sum up my thoughts:

1. The capabilities of the concessioners are directed towards their self-preservation and continuation. This comes first; in some instances we have some evidence of concern for the park concepts—but not much.

2. The park concept is limited to inherent qualities of the natural scene and to making it possible for citizens to participate in the experience.

3. The experience has never been defined in terms of the general public.

4. The Park Service has, at present, no alternative to the concessioner situation. Any action by the NPS to totally control the concessioner would probably result in the latter's extinction or withdrawal.

5. What would that involve—politically and in terms of visitors' demands and expectations? It would be a mess of extraordinary character!

Again, hence:

1. I see the only solution is for the NPS to completely and irrevocably take over all concessioner operations. I do not know if the NPS could actually administer the operations in detail but they might *lease* valid operations under strict control (where have I heard "strict control" before?). We assume some "operations" are valid.

2. I see the NPS as the sole arbiters of use and service and, of course, of "plan." The latter sounds fine, but the selection of *planners* is one of the really difficult tasks—especially for a government body.

3. IF YOU ARE TO ACCUSE ANY "BODY" OR ORGANIZATION FOR THE PRESENT SITUATION IN YOSEMITE, I THINK YOU MUST FIRST PUT THE FINGER ON THE NPS. This in no way condones the opaqueness and selfishness of MCA or any preceding concessioner. But the attack should be directed to where it belongs—right in the core of the NPS and the political and bureaucratic institutions. If you concentrate on the concessioner, I think you will weaken your point. You would do better to feel sorry for them! It is so easy to "point fingers." Then MCA can come back at you with the perfectly truthful statement that "the NPS demands our services...."

Please consider this as comment on a matter of principle: the principle of positive attack. I think we are all out for the solution of the same problem. The problem will not be solved by focusing your energies on MCA; I think you can dismiss them as an expected phenomenon in the context of the general confusion. In fact, the more we castigate MCA the more we invite sympathy for them (which they do not deserve). They came in under the Mather concept, and they function under the modern interpretations of that concept.

I believe that you have a great opportunity to hit the target by revealing the fundamental weakness of NPS policy and concepts and the dull and unimaginative forces that control it. You can't curse the virus—you try to save the patient! It is really a matter of where you point the finger.

WHAT does anyone really DO ABOUT Yosemite (or any of the parks)? You must not forget that you have 200,000,000 plus or minus people who "own" the parks. You and I know that only 1% (conservative) really *care* about the parks and what they represent. This is the real problem facing us; education (perish the term) of the great mass of people to better understand what the parks are all about. I am not too optimistic about this; recreation is still the prime motivation of visitation to the parks. I strongly promote the term "reserve" instead of "park" as I think it better defines the function of the areas.

From a letter to Robert E. Wilson, environmental writer, April 4, 1976

I take pleasure in sending you my thoughts and comments on the current Yosemite Master Plan. These are the culmination of considerations formed over a near-lifetime of close contact with Yosemite and the Sierra Nevada. I first came to Yosemite in 1916 and have visited the Park every year since then, including a number of years as a permanent resident (in the 1930s and 1940s). My professional work (which could not be practiced in a national park) obliged me to return to San Francisco in the late 1940s. We moved to Carmel in 1962 but our interest and contact with Yosemite has been maintained over all these years.

Also, I have visited and worked (photographically) in almost every national park and many of the national monuments as well. This includes Hawaii and Alaska. I feel it is important to approach any Master Plan for Yosemite with consideration for the objectives of the national park concept in entirety. I am aware of the variations of quality and function of the different areas but the basic purpose of the national park concept is *appropriate* protection and use; I am sure that the recreational functions of the Cape Cod National Seashore are, in most citizens' minds, quite different from the heroic natural values of Yosemite, Glacier Bay, or the Grand Canyon.

While Yosemite is perhaps the most beautiful and dramatic area of all, fresh thought and inspiration on the future of all the reserved areas is much to be desired. However, the purpose of this letter relates to Yosemite and I shall concentrate thereon. But I cannot avoid concern that any plan for Yosemite should reflect not the *status quo* of the old established parks but definitely introduce contemporary concepts such as are being applied to most recently established areas. This means that Yosemite

should be "returned" to a condition and use of an earlier day—a more pristine situation of emphasis on a higher standard of appreciation of the natural scene and a lesser emphasis on "expansion" and quasi-urban development. I am not urging a reduced *quality* but a simpler and more appropriate approach....

I do not trust random opinion and advice that is not based on superior training and experience. Every citizen has a right to express his opinion, but this opinion must be concerned with the realities of the larger scene. If the function of the National Park Service is protecting the national parks for future generations, it seems that decisions thereon should be formulated by true experts in the various fields involved. I know many young people who would close the parks to all uses except those related to foot travel! Some areas justify this rigorous restriction; certainly not Yosemite, which is a national shrine. That does not mean it may be exploited or used in any way that would impair its essential values. Limitation of visitation is an essential reality!... It is encouraging—and a moving experience—to stand at the Wawona Tunnel esplanade and look into Yosemite Valley; *no* evidence of man is visible (without a telescope). However, looking down from Glacier Point into Yosemite reveals a shocking complex of poor planning and development (especially at night when the Valley floor blazes with light like a rural community). However, in spite of all this development, the Valley itself is more beautiful than when I first came; it is clean, well-managed by the Service, free from the dust of earlier days, and the services are certainly superior. It should be made clear that what has been done—inappropriate as much of it is—has been done quite well. No matter how good the mechanics may be, the question remains—to what degree should they have been introduced in

the first place, if at all? This question is addressed to all who bear responsibility for the protection of Yosemite—and this includes the citizens as well as the administrators, the ecologists, and the planners.

I do not feel that adequate expertise has been involved in the formulation of the Plan(s). We should seek an [Frederick Law] Olmsted among the many gifted individuals working in the areas of planning today. However, another force than the planners is required; I recall an old Irish legend that the early Kings of Erin held court with a General on one hand and a Poet on the other. This may be apocryphal, but a good suggestion! The planners must have basic sympathy for the environment and an understanding of its potential appropriate bene-fits to all our people. I believe that the problem is not difficult conceptually, but it is quite difficult in implementation, demanding a high order of techni-cal and aesthetic capabilities....

In closing, I wish to make an appeal to most seriously consider the vital importance of taking truly strong action to initiate planning of forceful consequence. We have been too hesitant, too cau-tious, too politically "safe," too unimaginative, and too careless of the erosions of time and the grave dangers of delay. In spite of all the good things that have occurred in the recent past the national park principles are more vulnerable than ever before.

From a letter to William Whalen, Director of the National Park Service, July 15, 1979

❧

I want the private cars *out* of Yosemite—and I want *everything that is rationally feasible* [out]. I want to see some camping and accommodations retained; this experience of being in the Valley for an appropriate time should not be denied our people. But I feel at least 80% could be better managed at Foresta, Wawona, et al. The "nuts and bolts" aspects can be at El Portal.

From a postcard to Richard Leonard, member of the Board of Directors of the Sierra Club, November 7, 1979

List of Plates